IMAGES
of America

BLACK HILLS
GOLD RUSH TOWNS

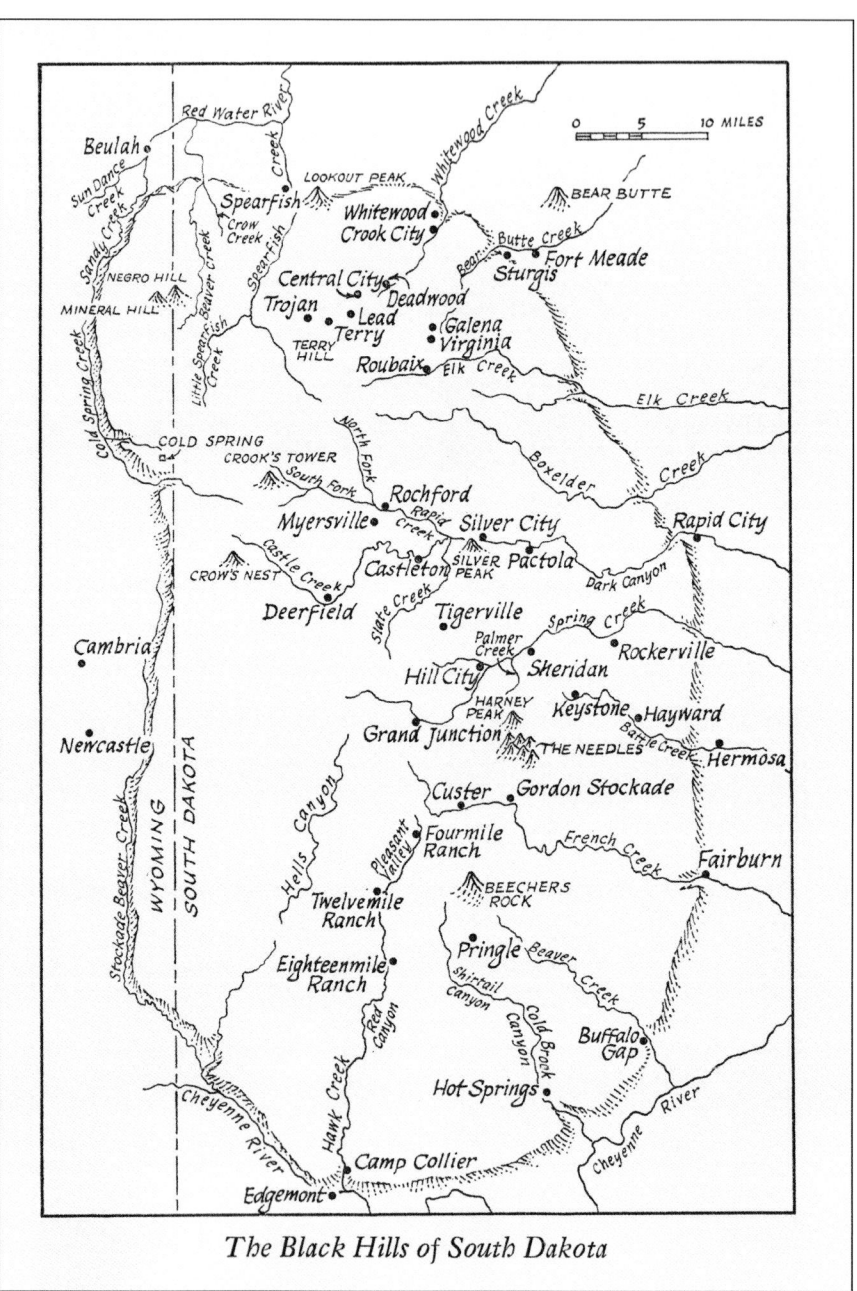

The Black Hills of South Dakota. This map appeared in *Gold in the Black Hills* by Watson Parker, published by University of Oklahoma Press in 1966.

On the Cover: Montana Mine. In 1879, Charles Dunphy discovered the Montana Mine north of Rochford. George E. Smith and other members of the Gregory Gold Mining Company built a 40-stamp mill. Amalgamation methods could not remove the gold from the ore, so the mine was closed. When it was reopened in 1901 and again in 1938, it continued to be unsuccessful. (Courtesy Minnilusa Historical Association.)

IMAGES of America
BLACK HILLS GOLD RUSH TOWNS

Jan Cerney and Roberta Sago
in cooperation with
the Minnilusa Historical Association

ARCADIA
PUBLISHING

Copyright © 2010 by Jan Cerney and Roberta Sago in cooperation with the Minnilusa
 Historical Association
ISBN 978-0-7385-7749-4

Published by Arcadia Publishing
Charleston, South Carolina

Printed in the United States of America

Library of Congress Control Number: 2009933646

For all general information contact Arcadia Publishing at:
Telephone 843-853-2070
Fax 843-853-0044
E-mail sales@arcadiapublishing.com
For customer service and orders:
Toll-Free 1-888-313-2665

Visit us on the Internet at www.arcadiapublishing.com

Contents

Acknowledgments		6
Introduction		7
1.	Custer, Hill City, and Keystone	9
2.	Rockerville, Mystic, Myersville, and Rochford	25
3.	Bear Gulch, Tinton, and Carbonate	41
4.	Rapid Creek, Placerville, and Robaix	55
5.	Galena	61
6.	Deadwood, Upper Deadwood Gulch, and Bobtail Gulch	71
7.	Ruby Basin and Bald Mountain Mining Districts	93
8.	Lead and Homestake	103
Bibliography		127

Acknowledgments

We owe a special thank you to Reid Riner and the Minnilusa Historical Association for the extensive number of photographs used in this book. All images that have not been given a credit line are from the Minnilusa Collection. Thank you also to the Black Hills Mining Museum in Lead and the Leland D. Case Library at Black Hills State University (BHSU) for a number of images used in this work. We also appreciate the gracious assistance of Mary Kopco, Carolyn Weber, and Rose Spiers of the Adams House and Museum and the photographs they provided. Thank you to Jeri and John Farhni for the use of the Fred Borsch Collection and for their dedication to preserving the history of Galena. Also thank you to Jace DeCory for providing us with the information on the Lakota legends. We also want to express our gratitude and admiration to Watson Parker and Mildred Fielder on whose work we relied heavily for this project. Any mistakes are our own, but you have inspired many a budding and a seasoned Black Hills historian. Last but not least, thanks to David Wolff for reviewing our work and trying to get us to get our facts straight. We hope the task was not too onerous and met with at least a modicum of success.

Introduction

Millions of years ago, the central core of the Black Hills erupted out of the plains, eventually to become an island in a sea of grass. Within its molten core, many geological processes were developing, one of which was the composition of a soft malleable substance known as gold. For centuries, this desirable medium of exchange had eroded down from the leads and been deposited among the gravel and sand of the streams. It lay hidden in the beautiful landscape of pine-covered hills and cool, sparkling streams. An eager eye could find gold in and around the numerous creeks flowing throughout the hills.

The Lakota, as well as other nations, consider the beautiful Black Hills the "heart of all that is" and their spiritual birthplace. The Lakota had been praying at sites around the Black Hills for thousands of years. According to Lakota legends, a long time ago, the people lived inside under ground. They emerged from Mother Earth at Wind Cave, whose gusts are regarded as the Breath of Earth. Other sacred sites include Buffalo Gap, where the buffalo are believed to emerge; Bear Lodge (Devils Tower), used for the Sundance; and Bear Butte, a site for prayer and vision quests.

In time, the news of gold leaked out. In 1874, the government commissioned at expedition to the Black Hills under the leadership of George A. Custer for the professed purpose of securing a site for a fort. However, many historians today suspect that the real purpose of the expedition was to verify the reports of gold. Horatio Ross, a member of the expedition, discovered gold along French Creek. Reports were filed, and the news spread to the newspapers. The Newton-Jenny expedition soon followed to confirm the reports of the Custer expedition. Even though the Fort Laramie Treaty of 1868 declared the Black Hills off-limits to the whites, prospectors came anyway. The army escorted the illegal miners from the hills, but they returned, and returned, in increasingly larger numbers. Finally the government gave up enforcing the treaty and began negotiations with the Sioux Nation for acquisition of the Black Hills. In 1877, the Sioux Agreement was imposed upon the Lakota, allowing miners and adventure-seekers to pour into the area in record numbers.

Since the Black Hills were isolated, the only way merchants could bring in goods and supplies for the miners was by wagon along one of the many trails that connected the Black Hills to the railroads or the Missouri River. The Cheyenne, the Fort Pierre-Deadwood Trail, the Bismarck, and the Sidney were some of the main routes freighting companies used to haul in supplies with the bull teams. It was not long before every gulch was occupied by placer miners with their rockers, sluice boxes, gold pans, and hydraulic operations. Wherever tents and cabins were constructed, a small mining camp with stores, hotels, and saloons bloomed.

By 1879, the miners had depleted the placer diggings and hard rock mining began. Placer mining had required very little capital for investment, so that even an ordinary man with little money and a few tools could sometimes strike it rich. A gold pan, a sluice, or a rocker and water along with patience and hard work could turn up some "color." On the other hand, hard rock

mining could only be developed after the would-be miner had invested large amounts of money in advance. Now that the Sioux Agreement was in effect, investors from the East or from foreign countries were only too happy to sink money in the lucrative mining venture. The capitalists began to build mills and shaft houses to mine the hard rock. The ore was laboriously dug out of the hills, deposited in ore cars, and transported on the tramlines and crushed in the mills. Complex processes released the gold from the ore. During this time, mines and towns sprang up in every gulch, and the people had hopes of striking it rich, not only with gold but also with silver, tin, and other minerals. Soon mills, hoist houses, treatment plants, tramways, and stamp mills began to alter the serene landscape of the Black Hills. Logging camps and sawmills worked around the clock to provide building material for the towns and mines that were developing at a rapid rate. Freight wagons hauled in mining equipment until the railroad reached the southern hills in 1886. Amazingly the frontier conditions and the area's isolation did not hamper the development of the gold-mining industry.

Between 1876 and 1930, an unknown number of mines were worked, and more than 400 towns rose and fell; however, a few of the mining towns have survived. The boom lasted for 25 years and then died, resulting in abandoned towns and mines, which eventually became know as the ghost towns of the Black Hills. The famous Homestake Mine, an exception, remained in operation until 2002. Other more lucrative mines operated sporadically throughout the war years. Even before the Depression of the 1930s, the mining industry suffered from the low price of gold and the high cost of labor and materials, as well as burdensome taxes. The plants dismantled and sold the materials for junk. The once $200,000 to $500,000 enterprises realized a salvage value of about $5,000 per plant. The Depression of the 1930s also lured miners and prospectors to the streams and gravel bars to search for gold once more.

As the mines played out, the population deserted the towns and moved on to other areas. The towns' buildings weathered and eventually toppled or decayed back to the earth. The Black Hills are littered with the tailings and strewn with relics of the massive mills and other mining buildings that once dotted the landscape. Trained eyes can detect the scars left on the landscape by former mining enterprises.

Just as mining era's equipment and structures left their mark on today's Black Hills, so did the personalities associated with this period. Everyone in the area was at least indirectly connected to the mining industry, whether as a storeowner, a hotel or restaurant proprietor, a livery stable man, or an investor. Many such characters have left their names and stories behind, becoming part of the region's history.

There is still gold in the Black Hills today, but much of the land is privately owned, so the eager prospector cannot freely roam and explore the hills as he once did. Nonetheless, veteran and novice prospectors alike use updated, effective equipment to placer mine on their private properties, still in search of the Black Hills's elusive gold.

One
Custer, Hill City, and Keystone

HORATIO ROSS. Even though gold had been found earlier in the Black Hills, Horatio Ross and William McKay were given credit as being the official discoverers of gold on French Creek near present-day Custer while members of the 1874 Custer expedition. When people found out that gold of lucrative quantities truly existed in the Black Hills, they defied a U.S.-Sioux treaty and flocked to the area in record numbers, changing the Black Hills forever.

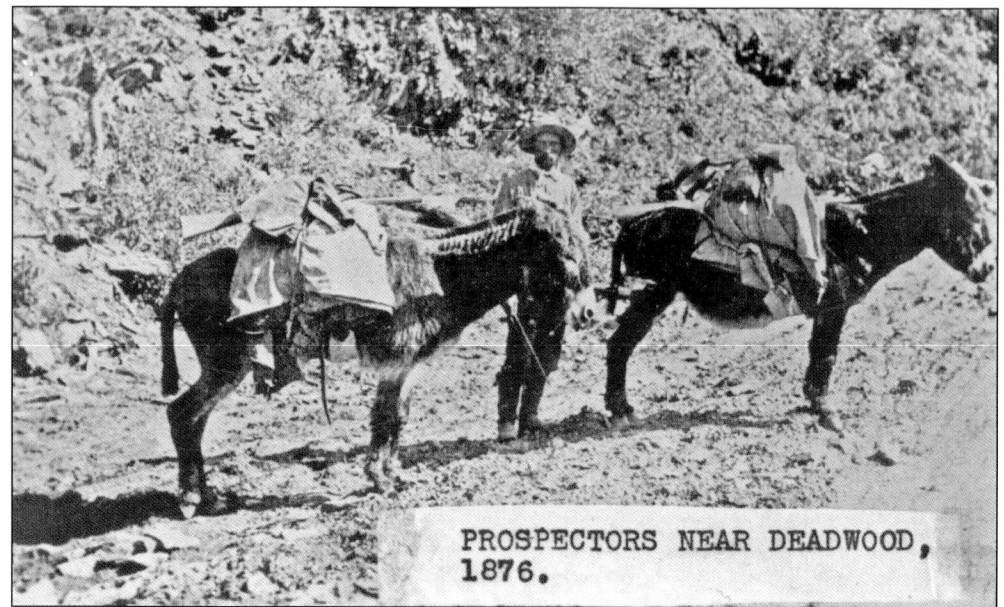

PROSPECTORS NEAR DEADWOOD, 1876.

PROSPECTOR. According to the Fort Laramie Treaty of 1868, no whites were to intrude on Native American lands west of the Missouri River. However, when news reached the world that there was gold in the Black Hills, prospectors and entrepreneurs set off to find their fortune. Government troops tried to halt their entrance onto Native American lands but finally gave up their attempts. In 1877, the U.S. government imposed the Sioux Agreement upon the Lakota, permitting fortune hunters access to the Black Hills. (Courtesy Leland D. Case Library, BHSU.)

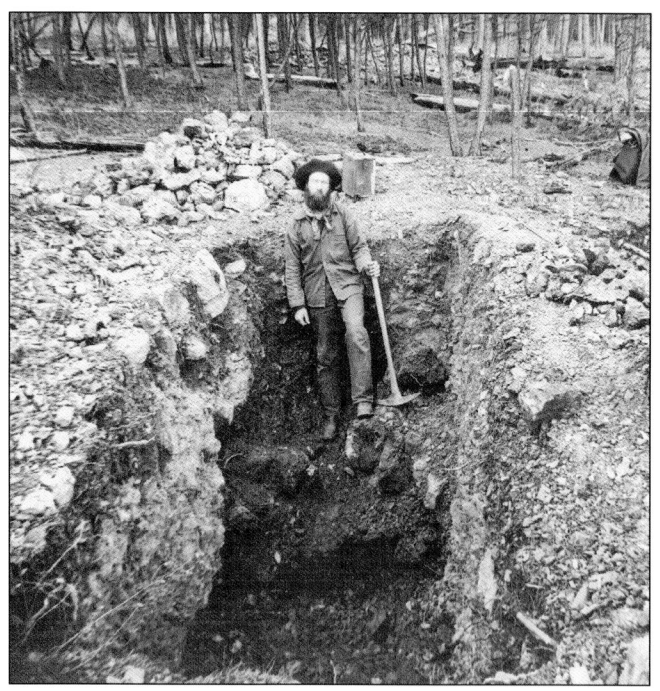

PROSPECTING. This prospector digs down to bedrock in hopes of finding gold. Heavier than the earth around it, gold sank down as far as it could until it stopped at bedrock. In the southern hills, the bedrock extended down to the point where the placer miners could not get to it all. However, near Deadwood, the bedrock tended to be within a few feet of the surface and was easier to reach. John McClintock, an early gold seeker and Black Hills pioneer, said that returning miners fleeing from the Black Hills during the Native American scare mistook the prospecting holes for graves.

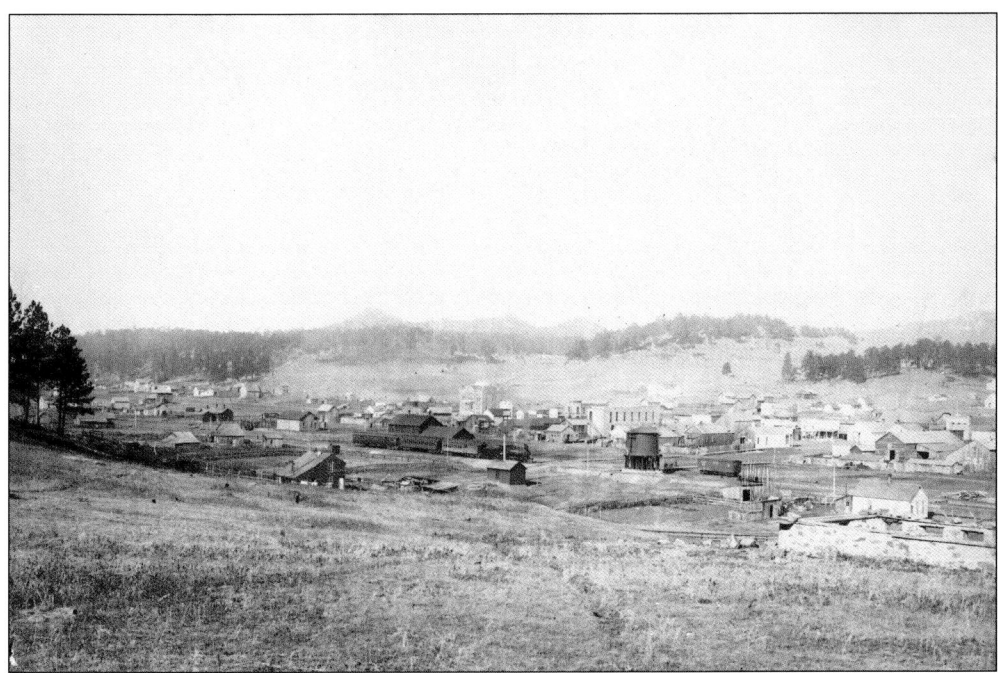

CUSTER CITY. Before General Crook removed the illegal miners from the Black Hills in August 1875, the miners planned and platted the town of Custer, so named in honor of General Custer. General Crook agreed to the miners' petition of leaving six or more of their men to guard their claims. The miners and other adventurers came back during the winter of 1875–1876 and constructed log and wood-frame buildings. The population during the spring of 1876 consisted of 6,000 to 10,000 inhabitants, but the rush to Deadwood Gulch reduced the number in a short while. The depopulation was temporary, as miners not able to locate claims returned. Soon lodes were discovered, open cuts blasted, tunnels dug, and shafts sunk, and approximately a dozen mines were developed in the Custer area.

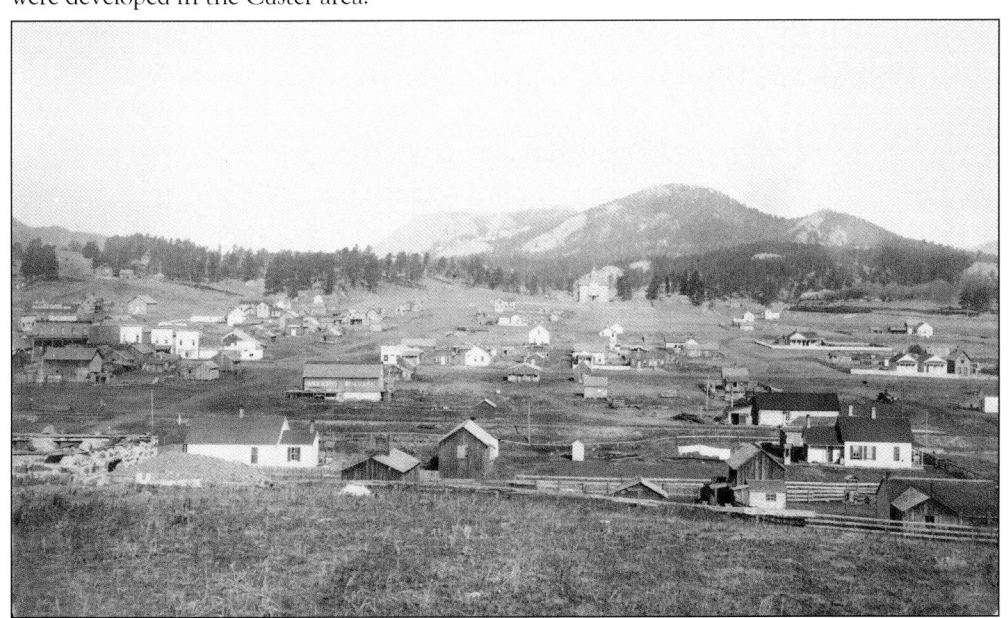

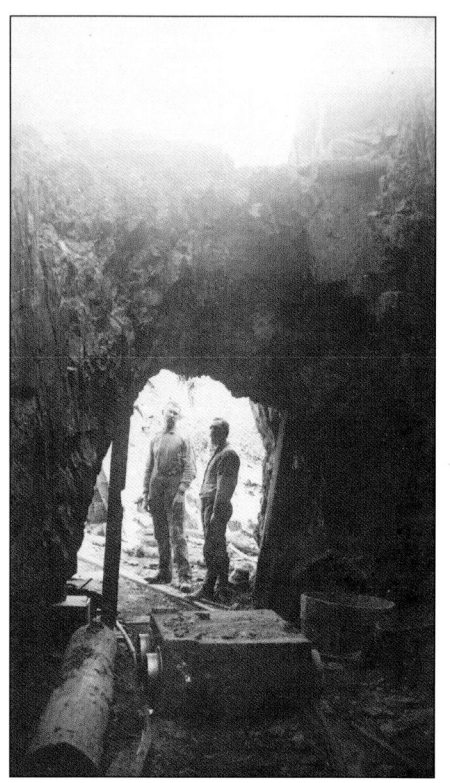

QUEEN BEE. F. H. Griffin discovered the Queen Bee Mine in 1879, and the surrounding town quickly grew. The mine was bonded to J. I. Case, who also manufactured farm machinery. The property was developed for only about two months. A Deadwood newspaper, the *Black Hills Daily Times* of June 5, 1880, reported, " Mr. Bates, agent of J. I. Case & Co., plow manufacturers of Racine, Wis., who bonded this mine for $60,000, some time since, and who have had a force of men at working developing it, has thrown up the contract, and has abandoned the work." Griffin teamed up with a Mr. Hall and purchased machinery for a 10-stamp mill, which operated for two months before closing for the winter. The property was then bonded to parties from Chicago for $55,000, but no action was taken. Col. D. Boyce bought the property in 1881 for the Michigan Southern Railway Company, but deeded it back to the original owners. In 1881, Edwin Loveland and James Jacoby bought two-third's interest in the property and added five stamps to the mill as well as a tramway to the mine. The Queen Bee operated sporadically up through the 1930s.

DRIVING PILES. These men are driving piles north of Custer. Sawmills and logging camps kept busy fulfilling the region's demand for lumber, whether it was for the railroads, flumes, towns, or other mining activities.

DOBBINS SAWMILL. Prior to the arrival of sawmills, buildings and sluices were constructed of logs or of whipsawed lumber. The construction of sawmills like this was welcomed by the miners, as the lack of milled wood had hampered the early placer operations. Black Hills sawmills could turn out 12,000 to 32,000 feet of lumber per day. In 1895, the Custer area had 20 steam sawmills and two planing mills, which all together employed 250 men. (Photograph by John Grabill; courtesy Library of Congress Prints and Photographs Division, LC-USZ62-34594.)

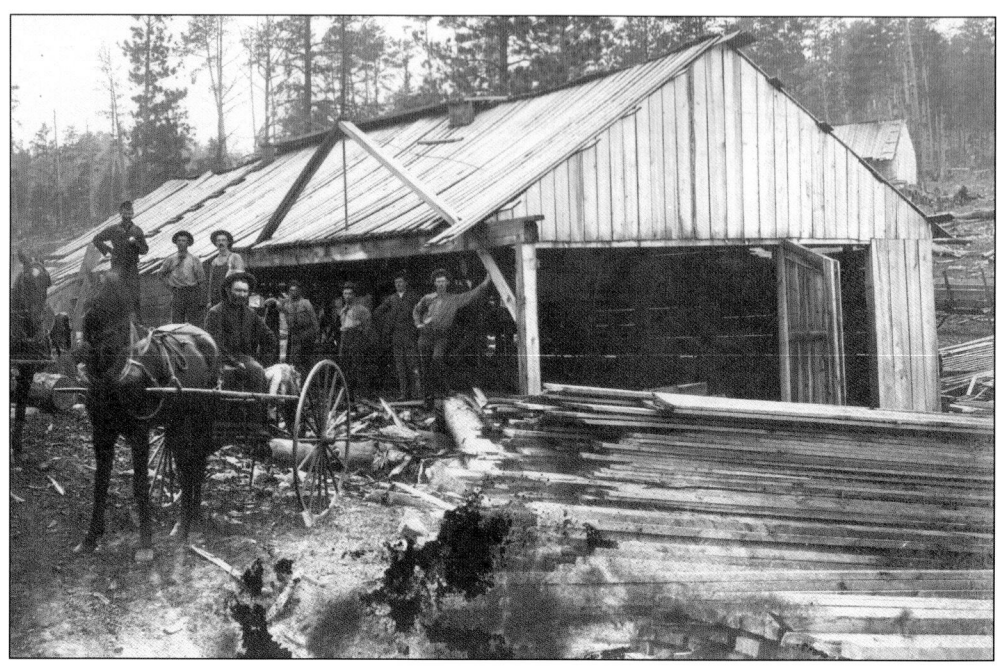

LOGGING CAMPS. Logging camps, like the ones pictured, provided needed logs and lumber for buildings, mining operations, and railroads. The *Black Hills Daily Times* reported that the logging camp of Sheridan, 5 miles northeast of Hill City, was alive with business. "Messrs Gates and Goughnour have three sawmills in active operation, furnishing lumber to build the great Black Hills Mining Company's flume, which commences on Spring Creek two miles above Sheridan." The project the paper referred to was the historic Rockerville flume.

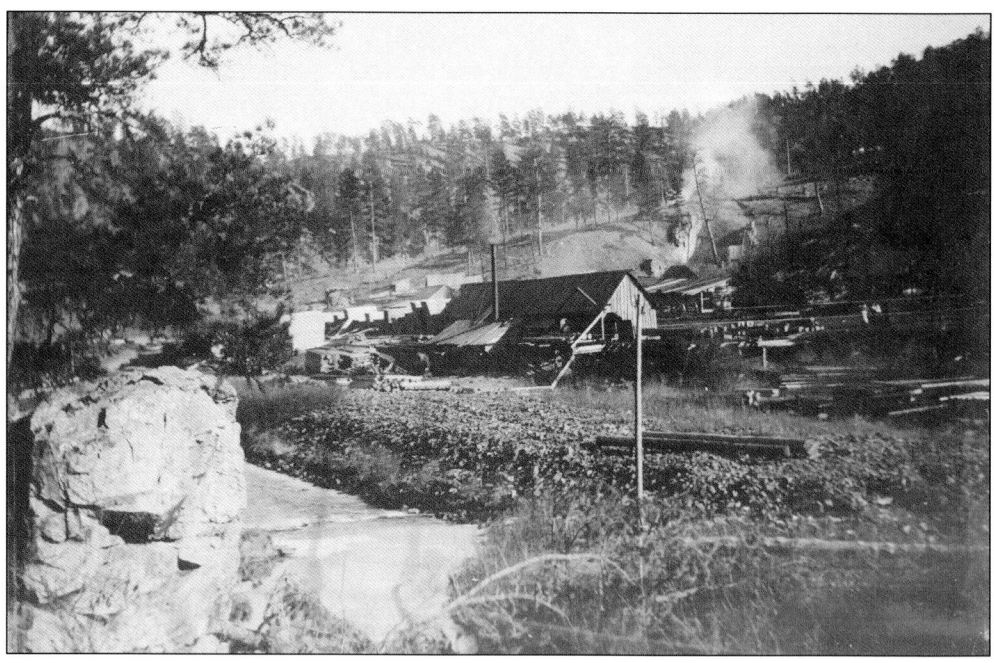

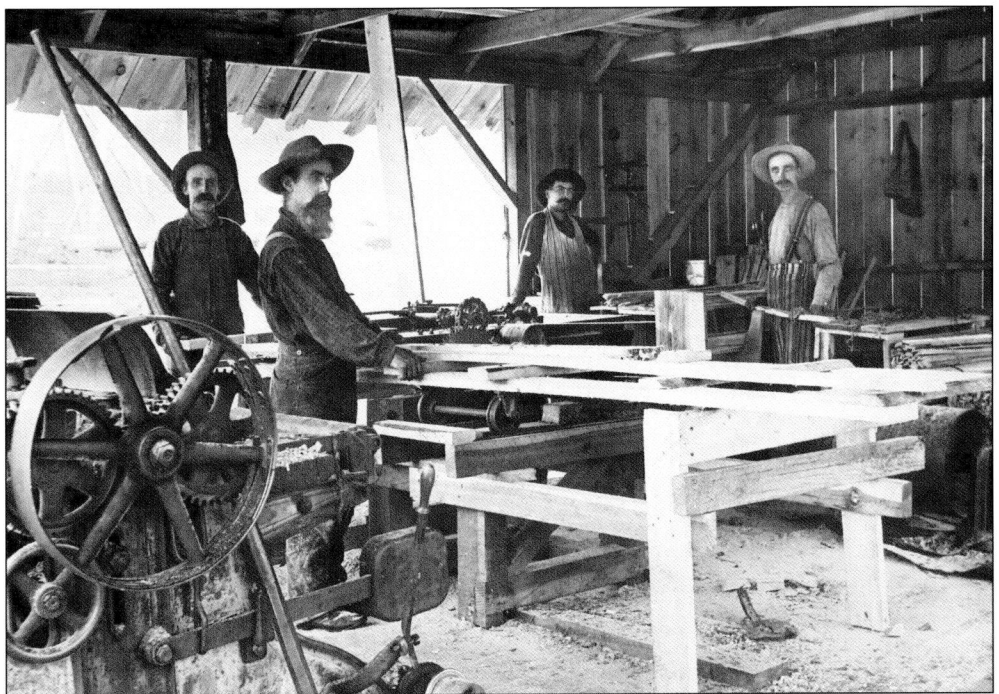

LUMBER MILL. The *Black Hills Daily Times* ran the following advertisement in its December 21, 1882, issue: "Five hundred men wanted at the end of the Black Hills Railroad near Rockerville, 15 miles south of Deadwood, to chop 40,000 cords of wood and make timber for the Homestake Company's mines, cut railroad ties, and work on the extension of the railroad. One dollar and twenty-five cents per cord paid for cutting wood. Fred T. Evans."

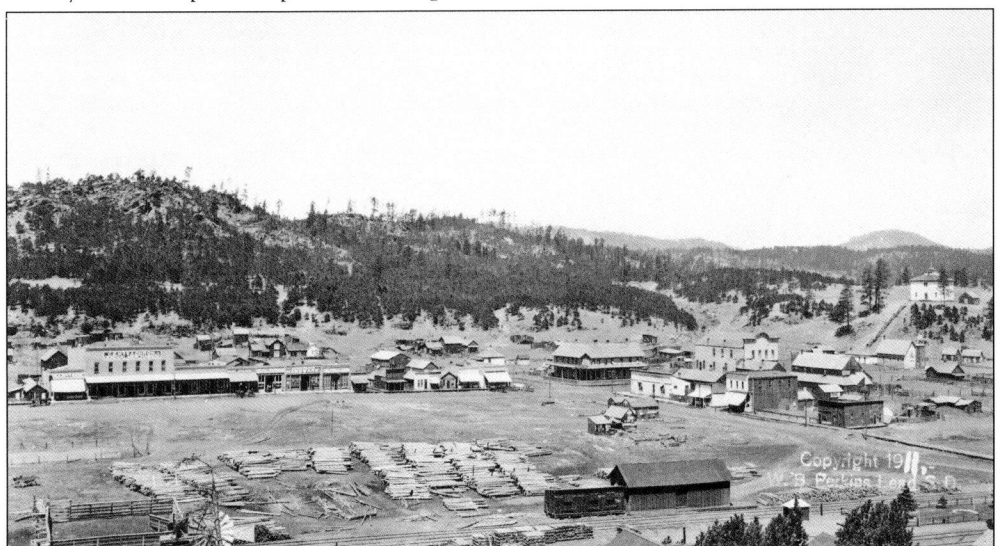

HILL CITY. Hill City began as a mining town, and like Custer, the population declined rapidly when the miners rushed to Deadwood Gulch. The discovery of tin gave the town a boost in 1883, and a mill was constructed near Hill City in 1892. However, in time, the English syndicate that was financing the endeavor withdrew from the scene. Today Hill City is a popular tourist town, famous for its 1880 train. (Courtesy Black Hills Mining Museum, Lead.)

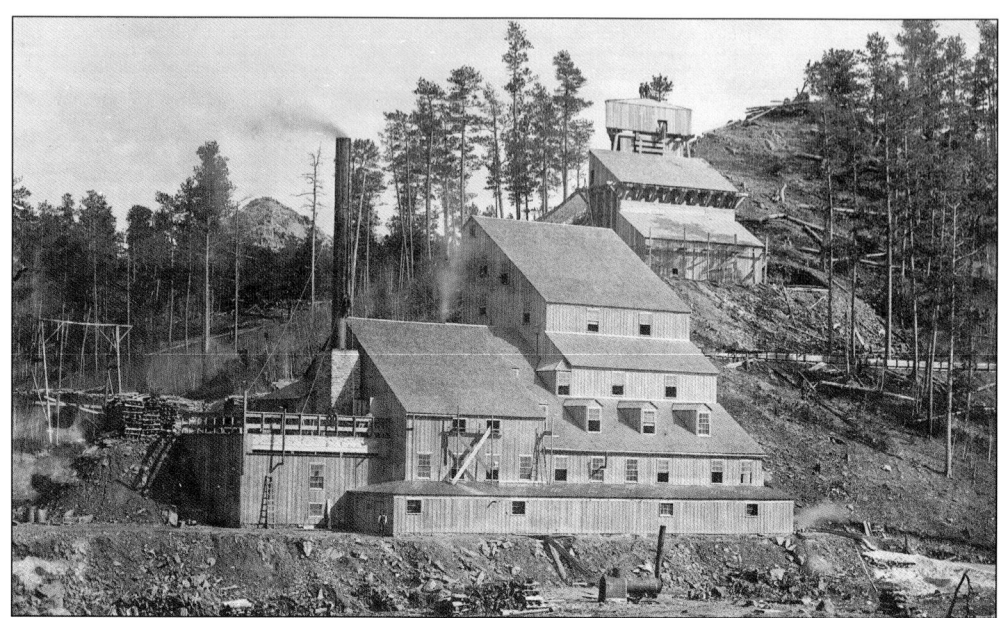

ETTA MINE. Dr. S. H. Ferguson, B. W. McDonald, A. J. Simmons, and Alexander Medill owned the Etta Mine, discovered by Ferguson and McDonald as a mica mine in 1883. A black ore was found in the mine, which contained an unknown mineral. After further examination, it was discovered to contain tin. The Etta Mine (3 miles from Harney City) and ledges near Hill City reportedly were rich with tin. English capitalists invested in the enterprise and built a large ore reduction plant near Hill City in 1891. After the plant's completion in 1892, it ran for several months but then shut down due to complications between American and foreign stockholders. (Above, courtesy State Archives of the South Dakota State Historical Society, below, courtesy Leland D. Case Library, BHSU.)

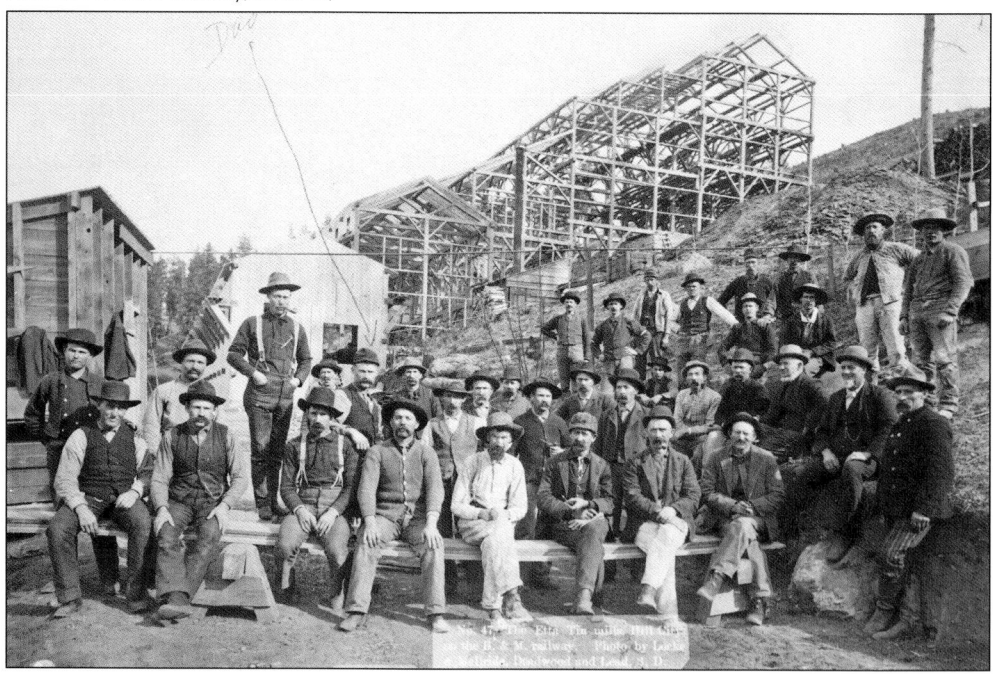

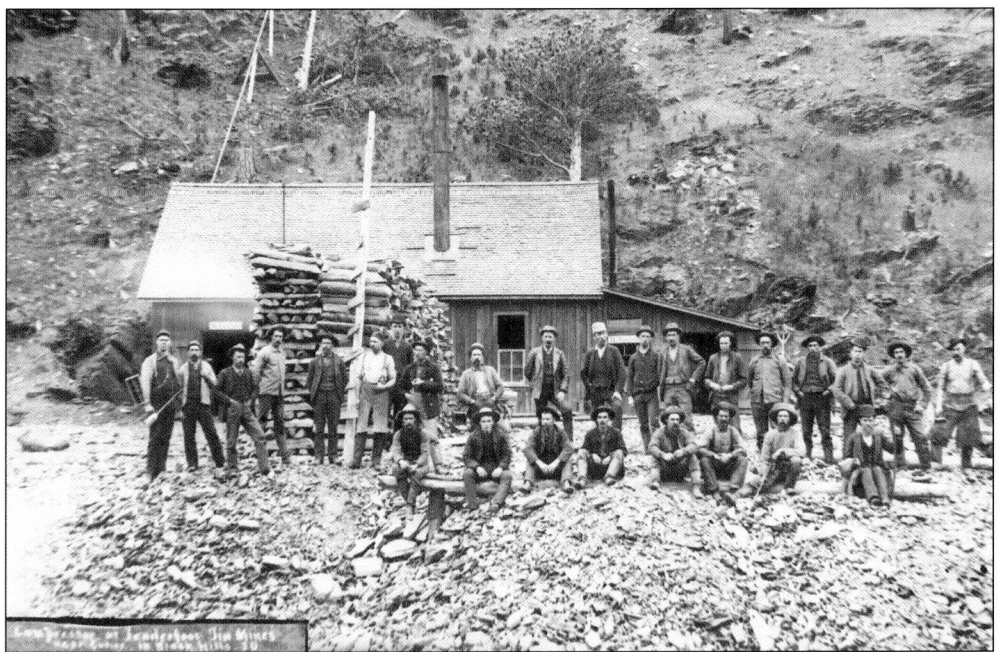

COMPRESSOR AT TENDERFOOT, 1883. The Tenderfoot tin mine, located between Hill City and Custer, originally belonged to the Harney Peak Tin Mining, Milling, and Manufacturing Company. Since 1891, the company owned nearly 1,100 tin deposit claims in the Black Hills. The *Black Hills Daily Times* commented in October 12, 1887, "The Harney Peak company has purchased a large number of prospects in the southern Hills, but has accomplished little or nothing in the line of development." The English stockholders brought suit against the Harney Peak Tin Mining Milling, and Manufacturing Company, stating that the tin did not have the value claimed by the promoters. The *Black Hills Daily Times* of July 11, 1894, stated, "The prevailing opinion of mining men in the vicinity of the Black Hills seems to be that tin exists there, but as practically no work has ever been done in the production of this metal, it is next to impossible to fix fair values on such property." The image below is of the Miner's Union in Hill City.

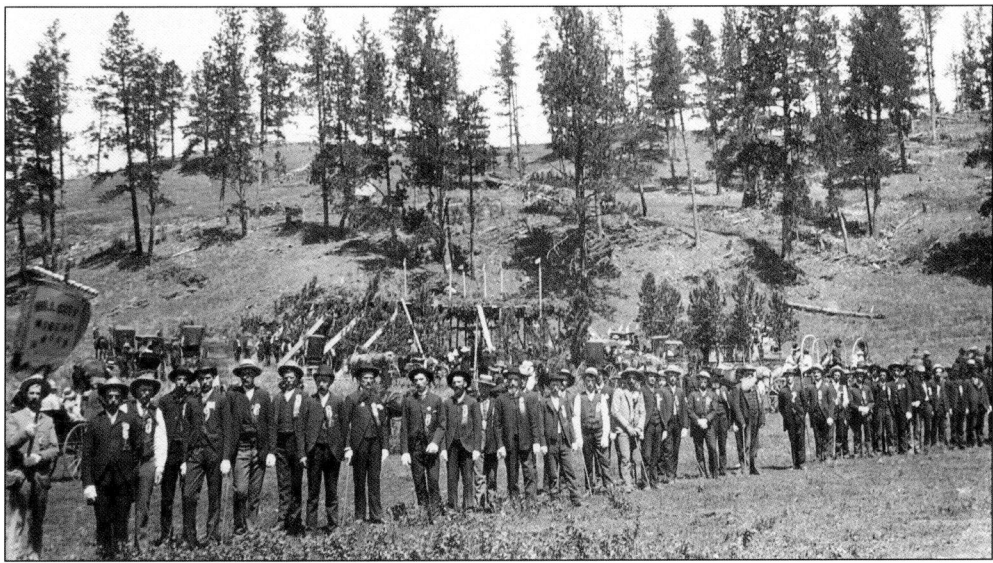

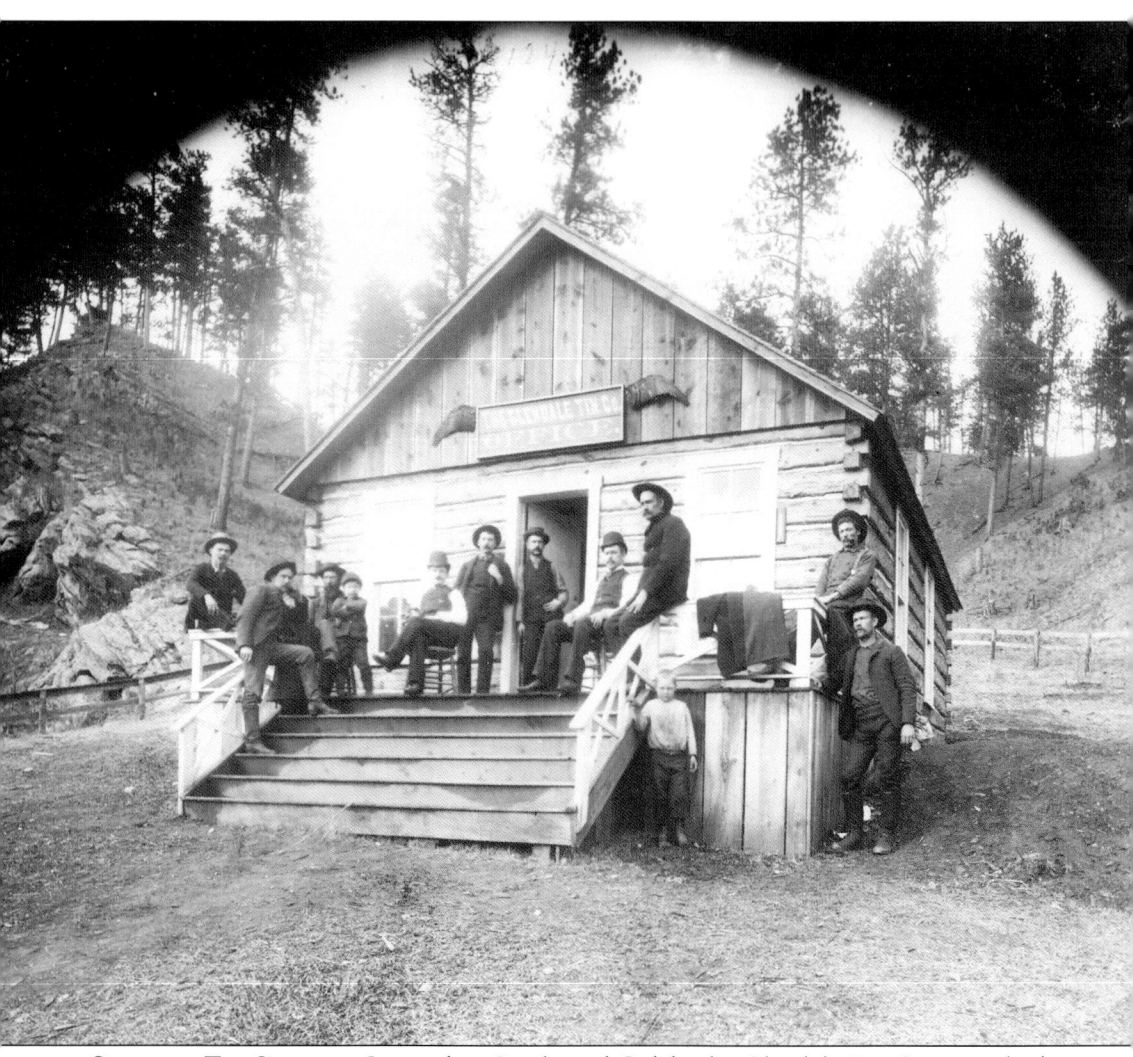

GLENDALE TIN COMPANY. Located in Greyhound Gulch, the Glendale Tin Company built a 150-ton tin mill. The *Black Hills Daily Times* in 1887 wrote, "Some 300 lode locations, together with placer claims, water rights, timber, mill sites, owned by the Harney Peak Tin Company of New York, have recently passed into the control of an English syndicate with a company formed in London with a capital of $10,000,000 for the purchase, development and operation of the mines . . . The English syndicate takes three-fifths of the stock and James Wilson and associates of New York hold two-fifths." A commission of the investors and experts visited the mines and saw more lodes and tin ore on the croppings than had been seen in all the rest of the tin mines of the world.

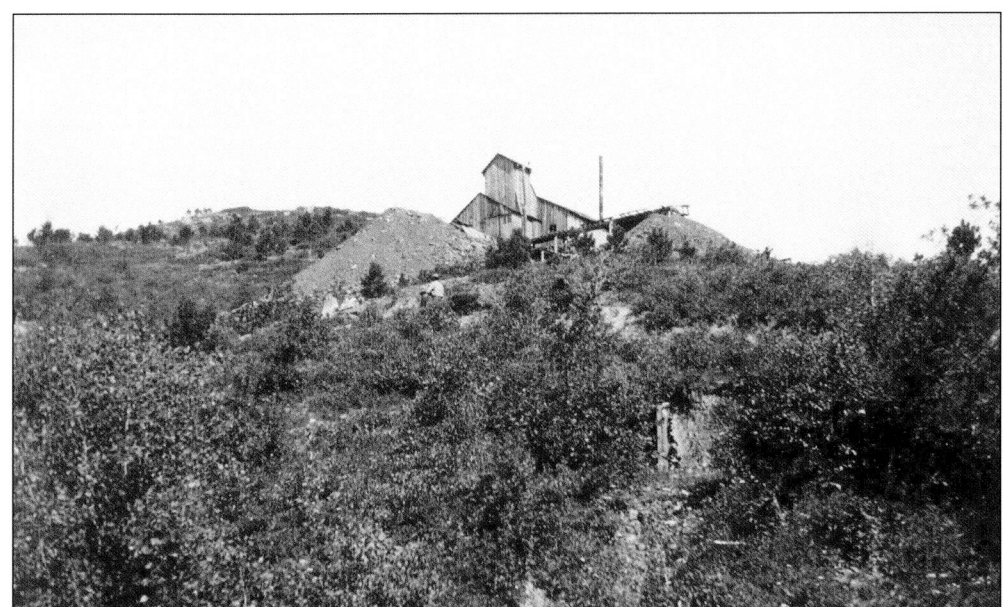

SPOKANE MINE. The Spokane Mine was located in Custer County southeast of Mount Rushmore. Established in 1890, it produced gold, silver, lead, zinc, and pegmatite minerals as well as the minerals galena, spalerite, and chalcopyrite. Only a few thousand dollars of production was recorded. The small town of Spokane grew up near the Spokane Mine. The mine ceased production in 1940.

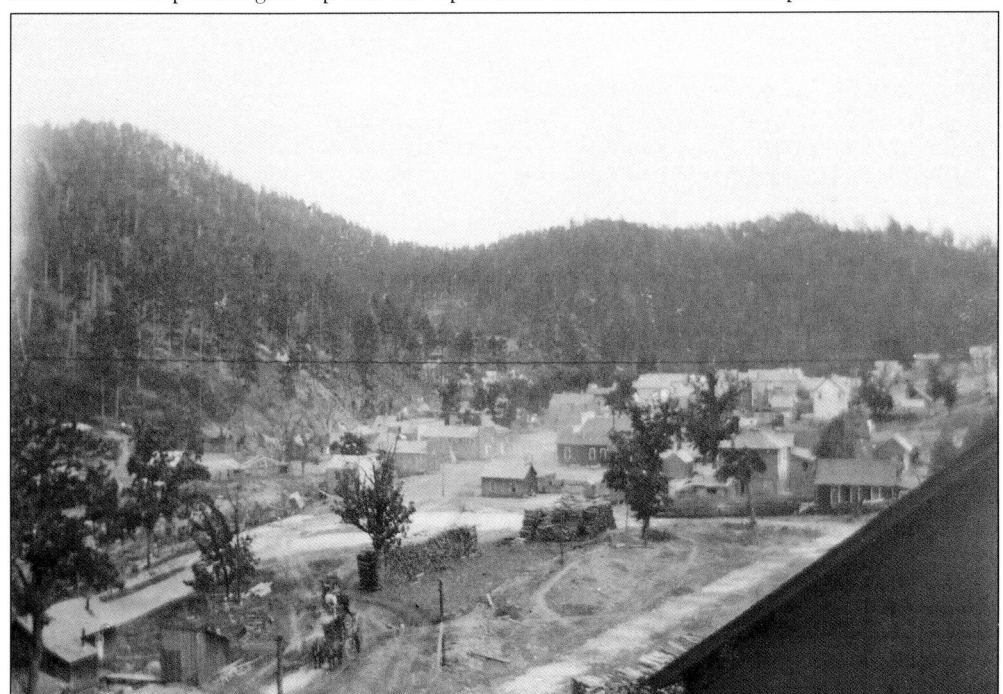

KEYSTONE IN 1898. Keystone, one of the later mining camps, organized in 1891. Situated about 7 miles from Rockerville, the gold discovery caused quite a stir for a while. Keystone began as a gold mining town, but an assortment of other minerals, along with the tourist trade, has kept it alive.

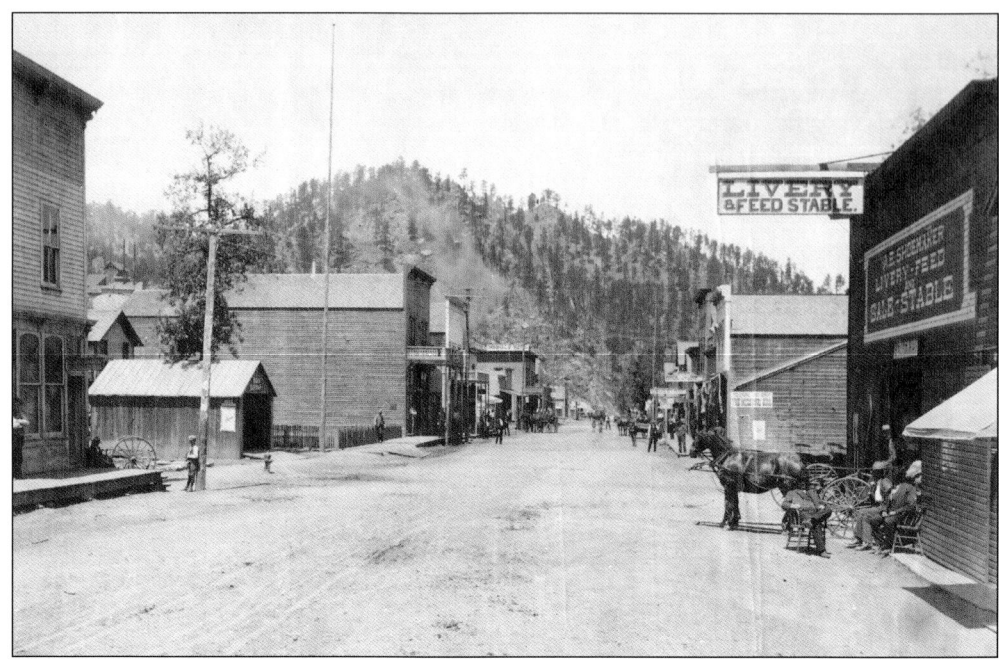

KEYSTONE. Fred Cross was thought to have named Keystone for a Masonic watch chain that he carried. Others believe that the town earned its name upon the discovery of the Keystone Mine, named because its miners thought they had found the key to the mother lode. The Holy Terror Mine also helped make the town famous and prosperous. William Franklin, Thomas Blair, and Jacob Reed located the Keystone Mine in 1891 and then sold it to St. Paul capitalists. The Keystone Mining Company built a 20-stamp mill. Franklin along with Thomas Blair located the Holy Terror lode in 1894. The Holy Terror Gold Mining Company was formed, bonding the Holy Terror with the Keystone Mine in 1897. After this, the two mines, dug only 500 feet apart, were joined by a tunnel. Together, they comprised the seventh-most productive mines in South Dakota.

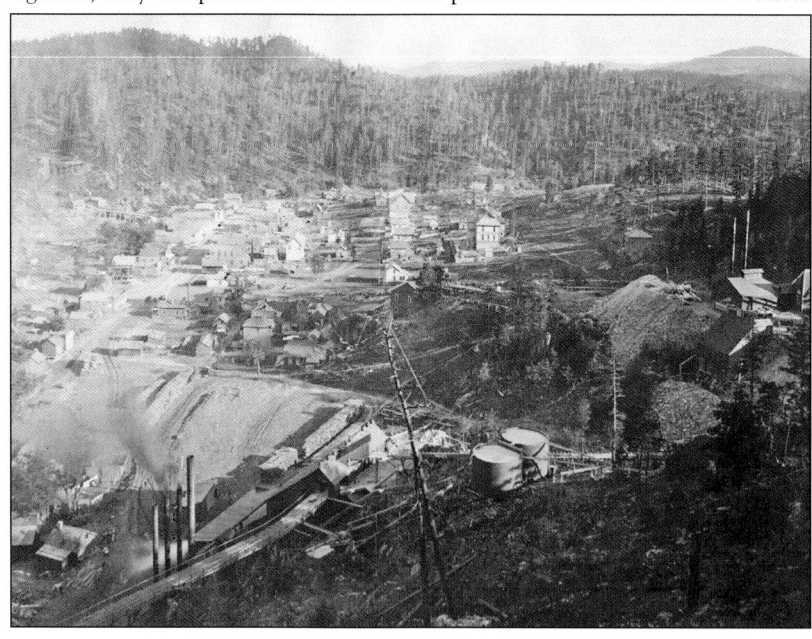

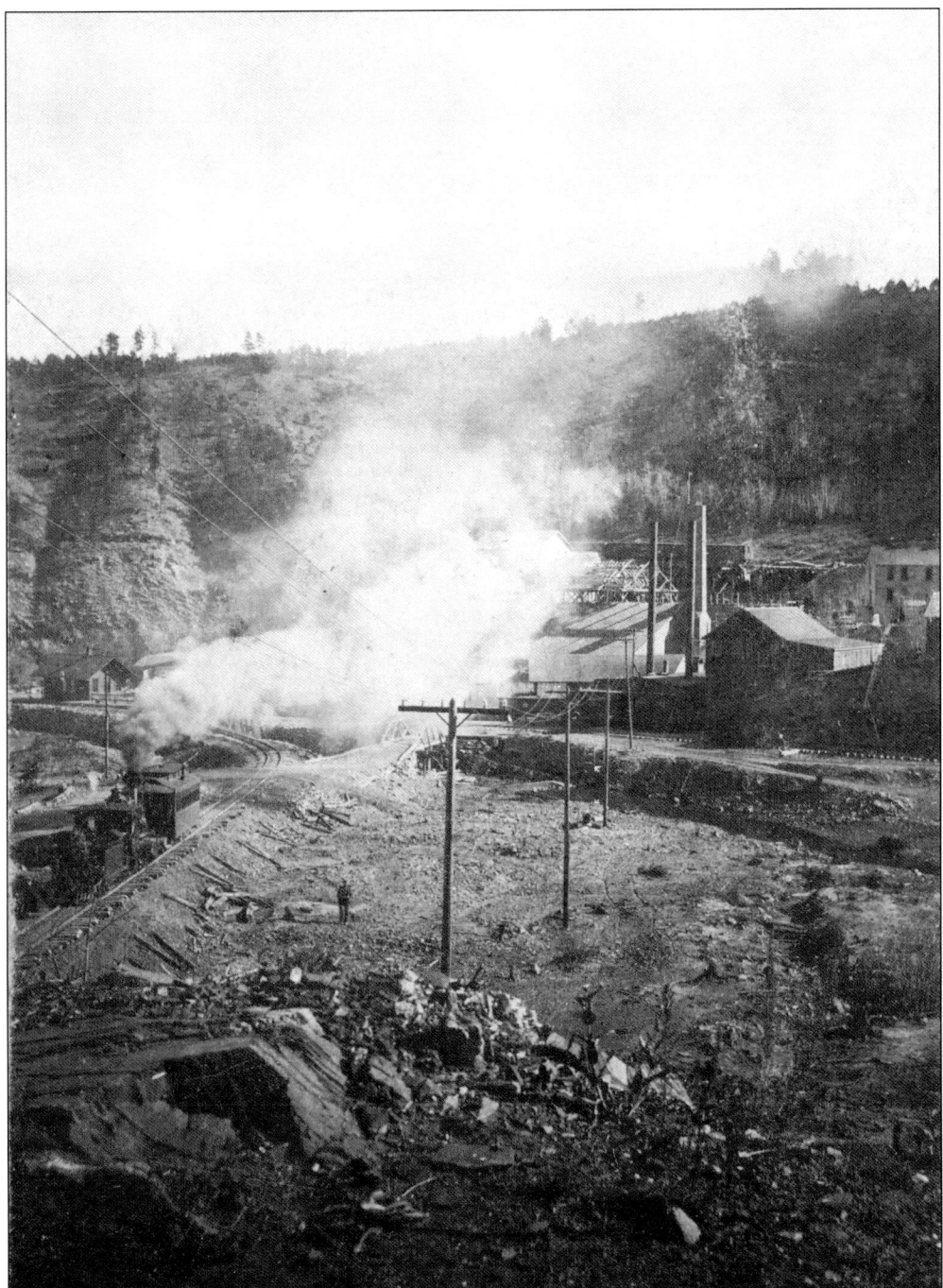

HOLY TERROR. In 1894, William Franklin's adopted daughter, Cora, picked up a piece of gold-bearing quartz while Franklin was digging postholes. According to local legend, William Franklin named the mine Holy Terror for his wife, who complained that other miners had named mines after their wives. Richard Hughes, who was involved with the mine, wrote that Franklin was known as "Rocky Mountain Frank," possessed a rough exterior, and often frequented the saloons. His wife, Lucy, came looking for him on occasion and gave him a tongue-lashing when she found him.

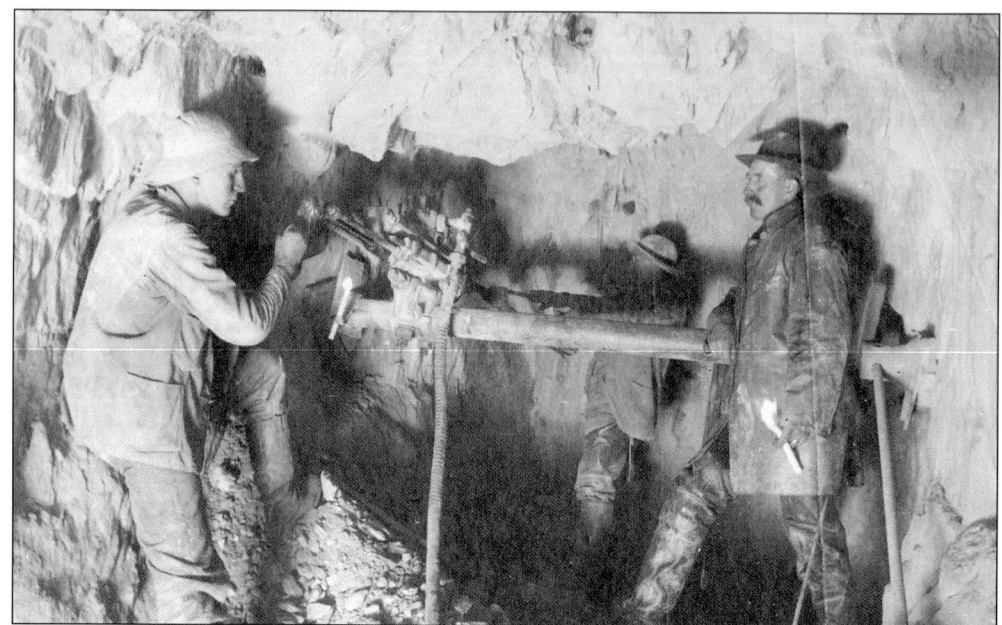

DRILLING AT THE HOLY TERROR. The Holy Terror experienced its share of problems, living up to the mine's name. In 1901, a faulty compressor pumped toxic gas into the mine, killing three workers. The subsequent lawsuits and other problems caused the mine to shut down in 1903. It reopened for a time in 1906, 1920, and in the 1930s.

HOLY TERROR MINE OFFICE. The mine office stills exists today. It is located in Keystone next to Halley's general store. Like other mines in the area, the Keystone mines roared back to life during World War II. Minerals other than gold or silver were needed for the war effort.

HOLY TERROR'S OWNERS. Pictured here are the Holy Terror Mine (above) and the owners of the mine (below). From left to right are Tom Blair, Fred Amsbern, John Fayel, and Bill Franklin. Franklin and Blair located the lode and then sold it to Fayel, John George, and other Milwaukee capitalists who were known as the Holy Terror Gold Mining Company.

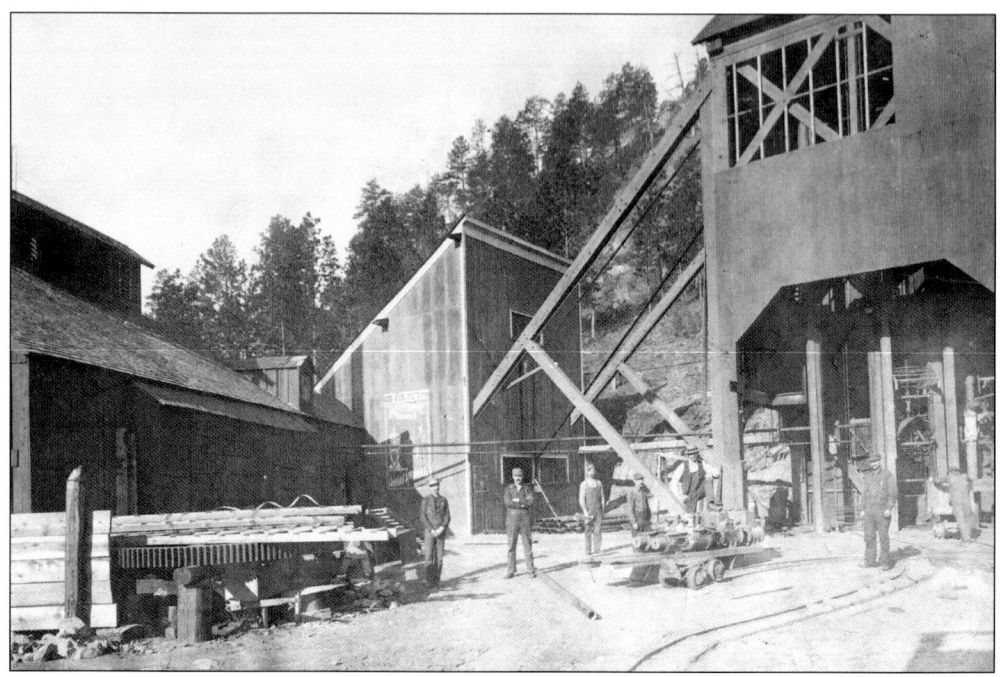

HOLY TERROR WATER. Excess water has always been a problem for the Keystone mines. (The town was well supplied with water pumped out of the Holy Terror Mine.) All the pumping was worth it: between $2–$3 million worth of minerals was mined here between 1892 and 1894.

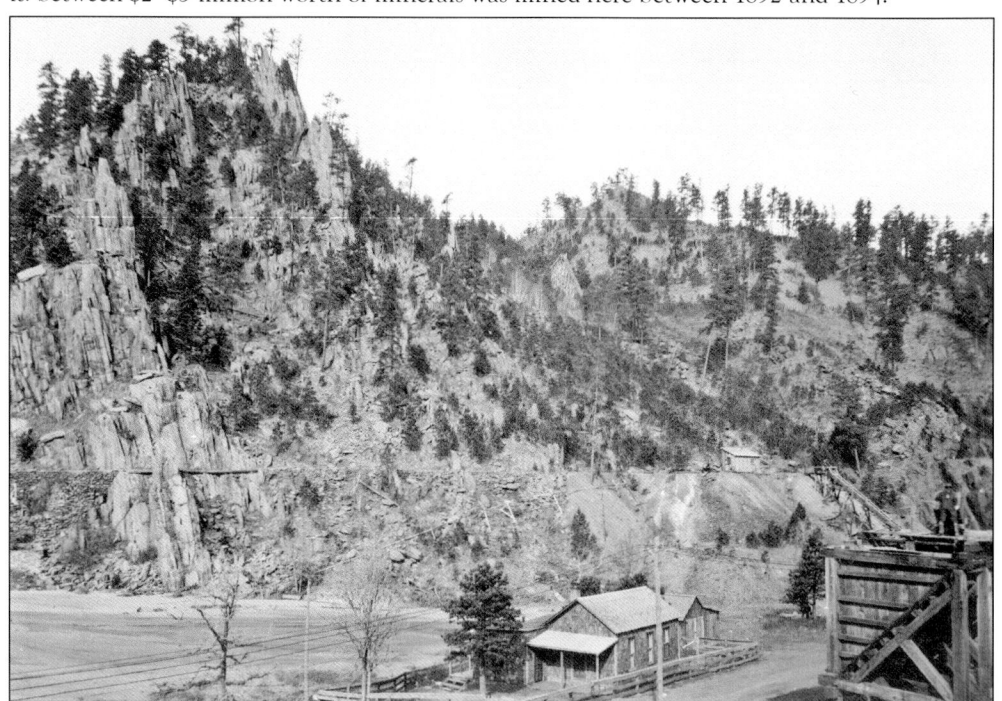

COLUMBIA MINE. Located on the northeast edge of Keystone, the Columbia Mine was begun in 1876 but not developed until 1909 after an 18-inch vein of gold was discovered. In 1927, the Columbia was consolidated with the Holy Terror, the Bullion, and the Keystone mines.

Two

Rockerville, Mystic, Myersville, and Rochford

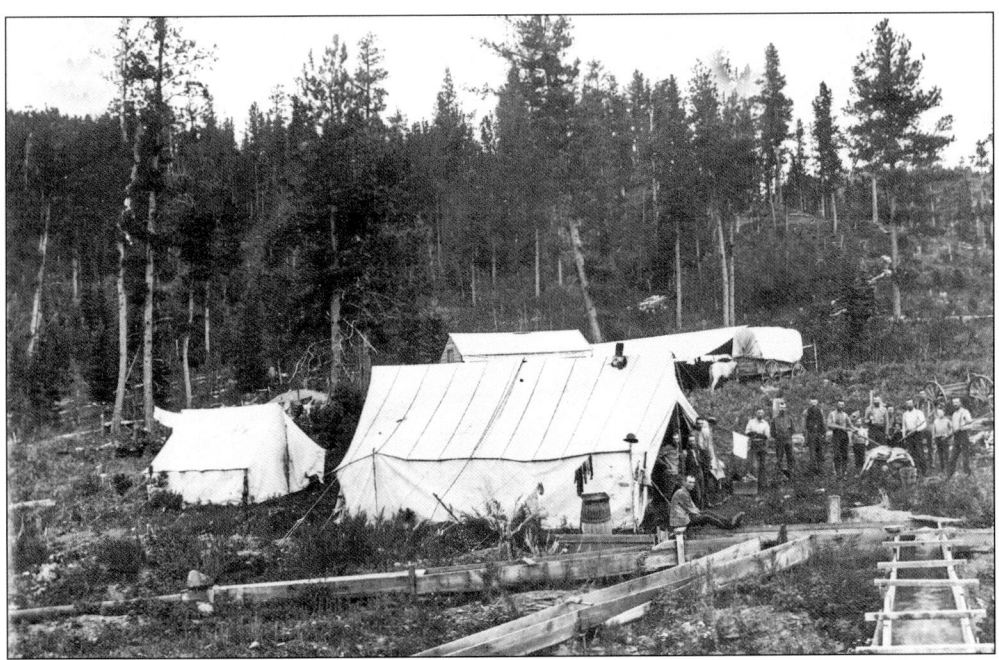

ROCKERVILLE MINING CAMP. Sluice boxes appear in the foreground of this early mining camp. When there were large amounts of gravel to wash, the placer miner used a sluice box, requiring an abundance of water. When water was not available nearby, the miner either damned creeks upstream, dug ditches, or built flumes on the sides of canyons to bring in water. When positioned on an incline, the water carried the gravel down the sluice and caught the gold in the riffles, which were made of perforated board. Only 60 percent of the gold in the ore would be caught by sluicing.

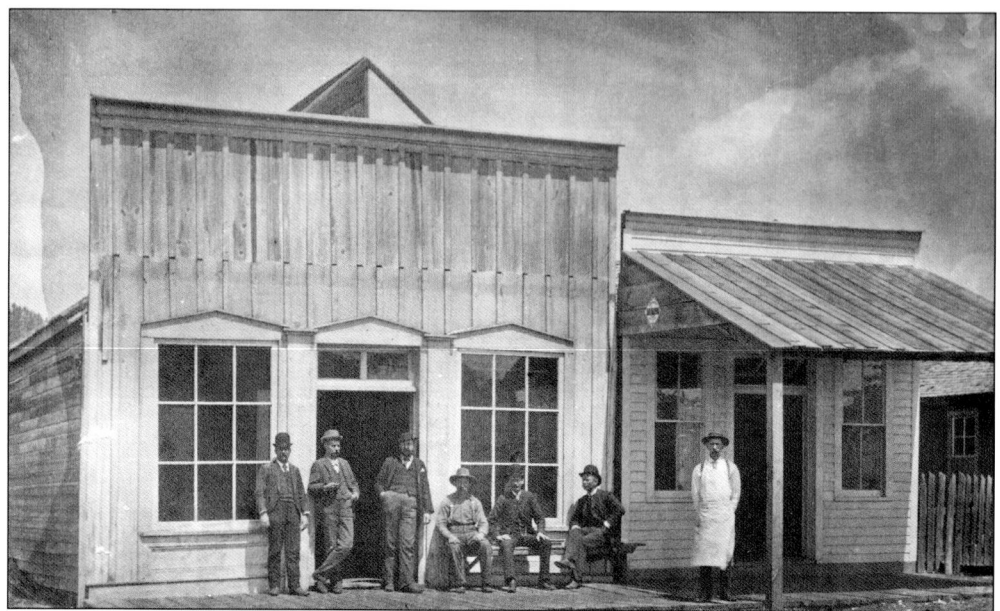

ROCKERVILLE. In 1876, William Keeler discovered gold in the Rockerville area, located 13 miles southwest of Rapid City. Since water was scarce, the prospectors used rockers to retrieve the gold, hence the name Rockerville. The rich deposits were located in a 6-mile square. The *Black Hills Daily Times* of May 29, 1878, reported, "The foundations of the stamp mill are nearing completion . . . Some of the cement here is very rich, and will without doubt pay well. . . . Building is lively; twenty-five new cabins being in course of construction. Bull teams are busy hauling logs and pay dirt. Rocking and sluicing is in active operation, and everything is moving slick as a feather bed."

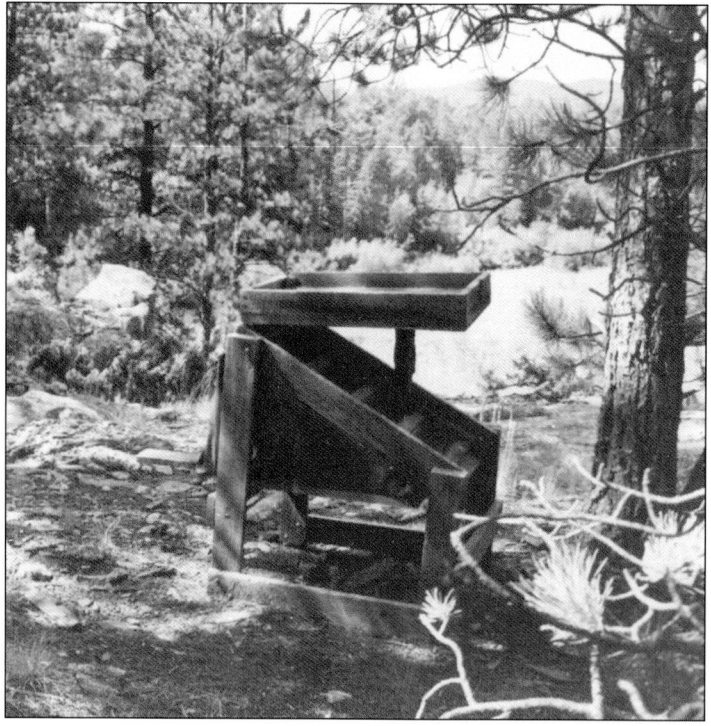

ROCKER. This water-saving rocker contained a sieve onto which the miner shoveled the gravel, mixed it with water, and removed the largest pieces of the gravel rock. The mud, sand, and water flowed downward toward the bottom of the rocker to be mixed by baffles as another miner rocked the placer device. Then the mixture flowed over riffles, which caught the heavy gold. Finally, what gold was not caught in the riffles ran with the mixture over an old blanket or a piece of unwashed wool, which captured the fine, precious particles.

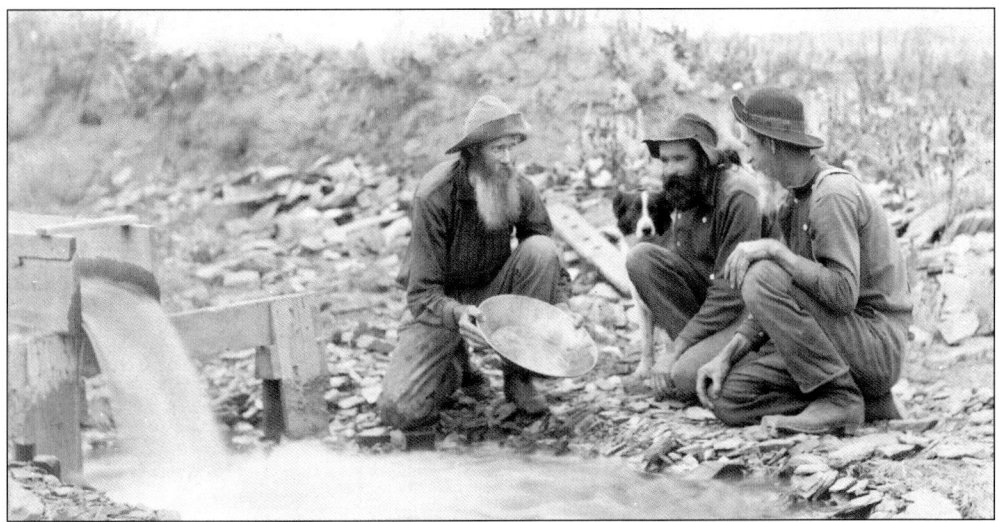

GOLD PANNING. With skill, practice and a deft hand, the prospector swirled his gold pan full of gravel, sand, and water, taking out the large particles, then, if lucky, displayed the fine gold in a half moon at the top of his pan. The heavy gold, if any, sank to the bottom. Carefully he retrieved these specks of gold with his finger, a matchstick, or tweezers and stored them in a vial or leather bag. Three men identified as Martin V. Spriggs, Jackson Lamb, and Patrick Dillon are panning in this image. (Photograph by John Grabill; courtesy Library of Congress Prints and Photographs Division, LC-USZ62-7120.)

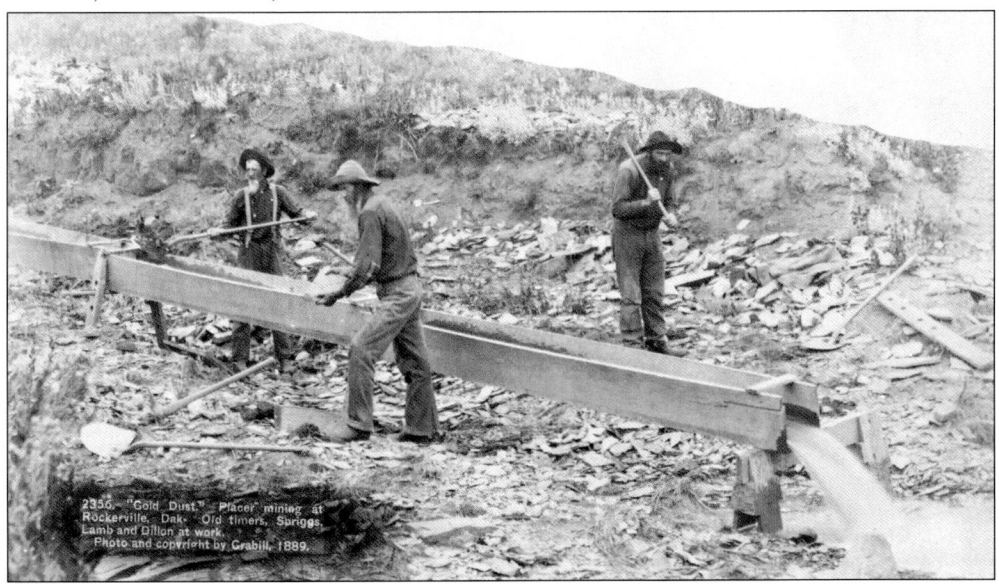

PLACER MINING, 1889. Martin V. Spriggs, Jackson Lamb, and Patrick Dillon use a sluice box near Rockerville. Gold that had originally been embedded in the rock had eventually eroded out from the ledges to settle in the streams and gravel bars. The first miners were intent on extracting the gold from the alluvial gravels by using placer mining techniques, which required little capital and few tools. Gold pans, rockers, sluice boxes, and later hydraulics became the common methods. When the placers were exhausted, experienced miners with capital began to develop the hard rock mines. About 70 percent of gold deposits were found in quartz. (Photograph by John Grabill; courtesy Library of Congress Prints and Photographs Division, LC-USZ62-19496.)

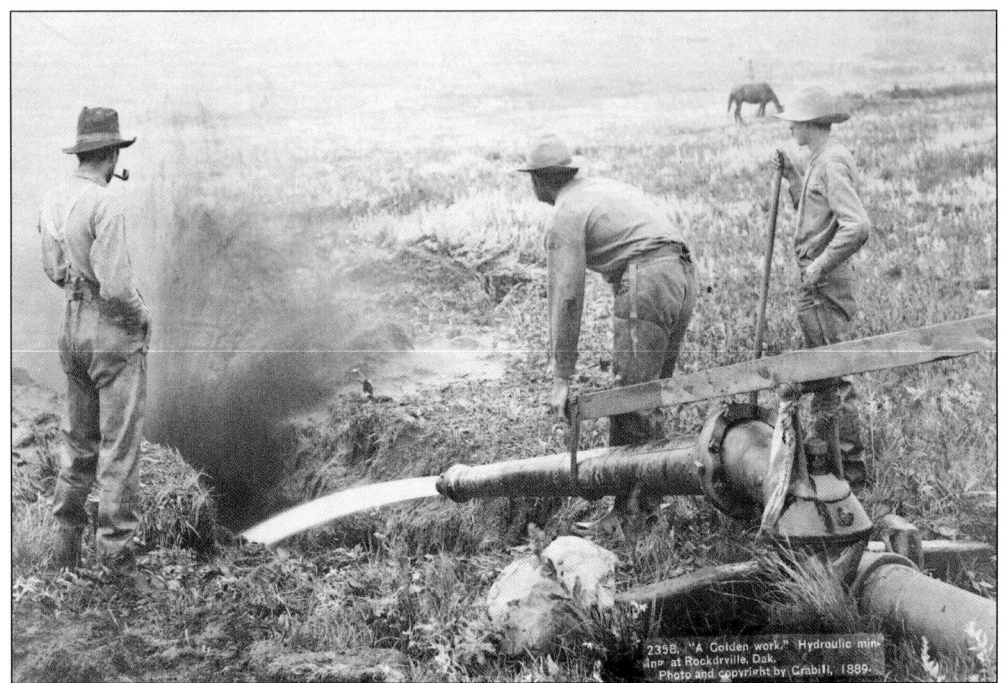

HYDRAULIC MINING. Rockerville's dry placer area used hydraulic power. The pressure of the water forced through nozzles broke down the chunks of gold-bearing material. The Black Hills Placer Mining Company formed in New York and built a 17-mile flume at a cost of $250,000–$300,000 to bring water from a Spring Creek dam near Sheridan to Rockerville. In 1880, the company hired Ambrose Bierce, a Civil War veteran and budding short story writer, to become the general agent of the Black Hills Placer Mining Company. Regardless of Bierce's efforts to straighten out mismanagement, the hydraulic enterprise proved to be a financial failure. (Photograph by John Grabill; courtesy Library of Congress Prints and Photograph Division, LC-USZ62-11775.)

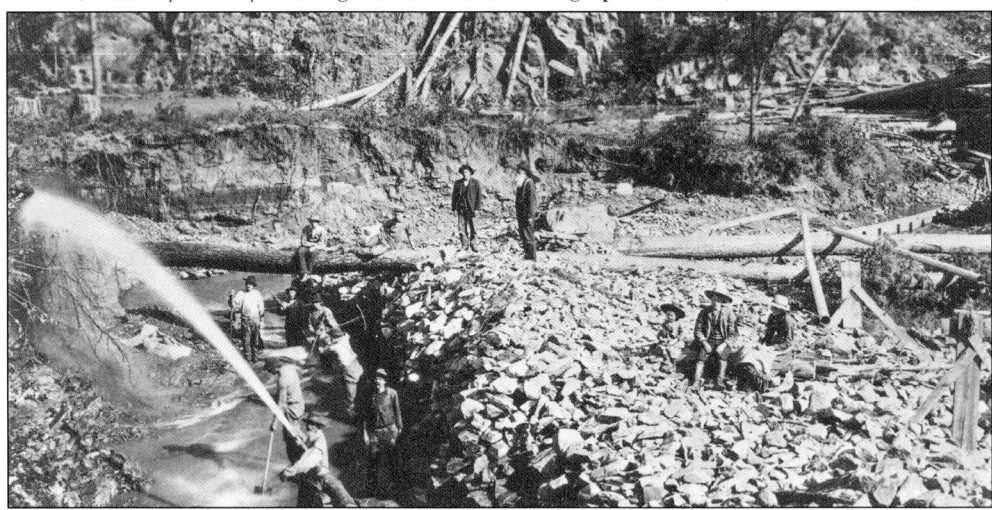

HYDRAULIC PLACER MINING. The June 11, 1879, issue of the *Black Hills Daily Times* asserted, "There is almost a township of land covered by these high placers and which will eventually yield bountifully under the pressure of the hydraulics." By 1881, hydraulic mining enterprises were progressing in some locations around the Black Hills, including Rockerville, Deadwood, and Lead.

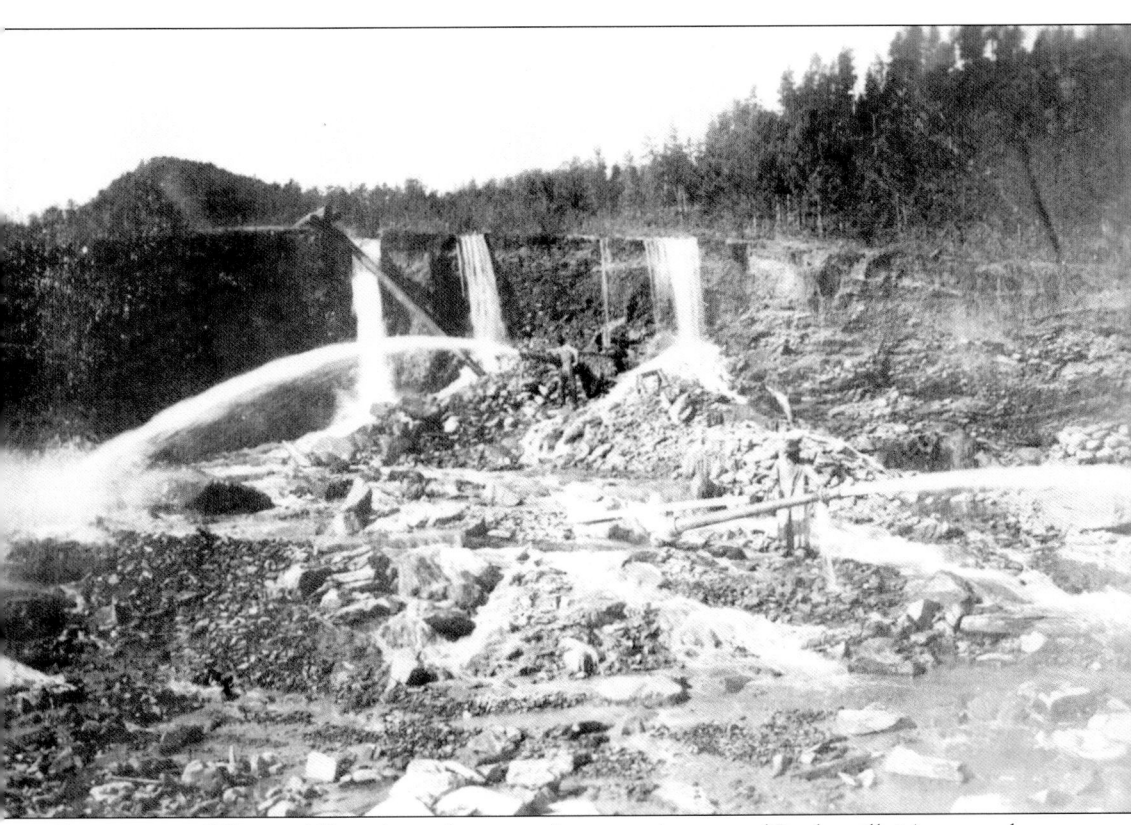

ROCKERVILLE. What could have been the topic of conversation around Rockerville? Among other obvious concerns, it could have been the Rockerville flume, seen above carrying water that is spilling over the sides. The flume project initiated quite a scandal. A writer for the *Black Hills Daily Times* on June 25, 1880, wrote, "Capt. West has been 'blowing in' his wealth and good name on this reputed daughter of his, who is none other than a Mrs. Carl who came here last summer with her husband from Omaha. She will be remembered as a very smooth looking young woman. . . . It has been charged that Capt. West had let contracts at double the figures that the work could have been done for, and of course it is the natural presumption that he stood in with the profits." West's action led to a trial, which was reported about in the *Black Hills Daily Times* July 13, 1880, issue. The case of the *Territory v. Captain West* charged West with embezzlement.

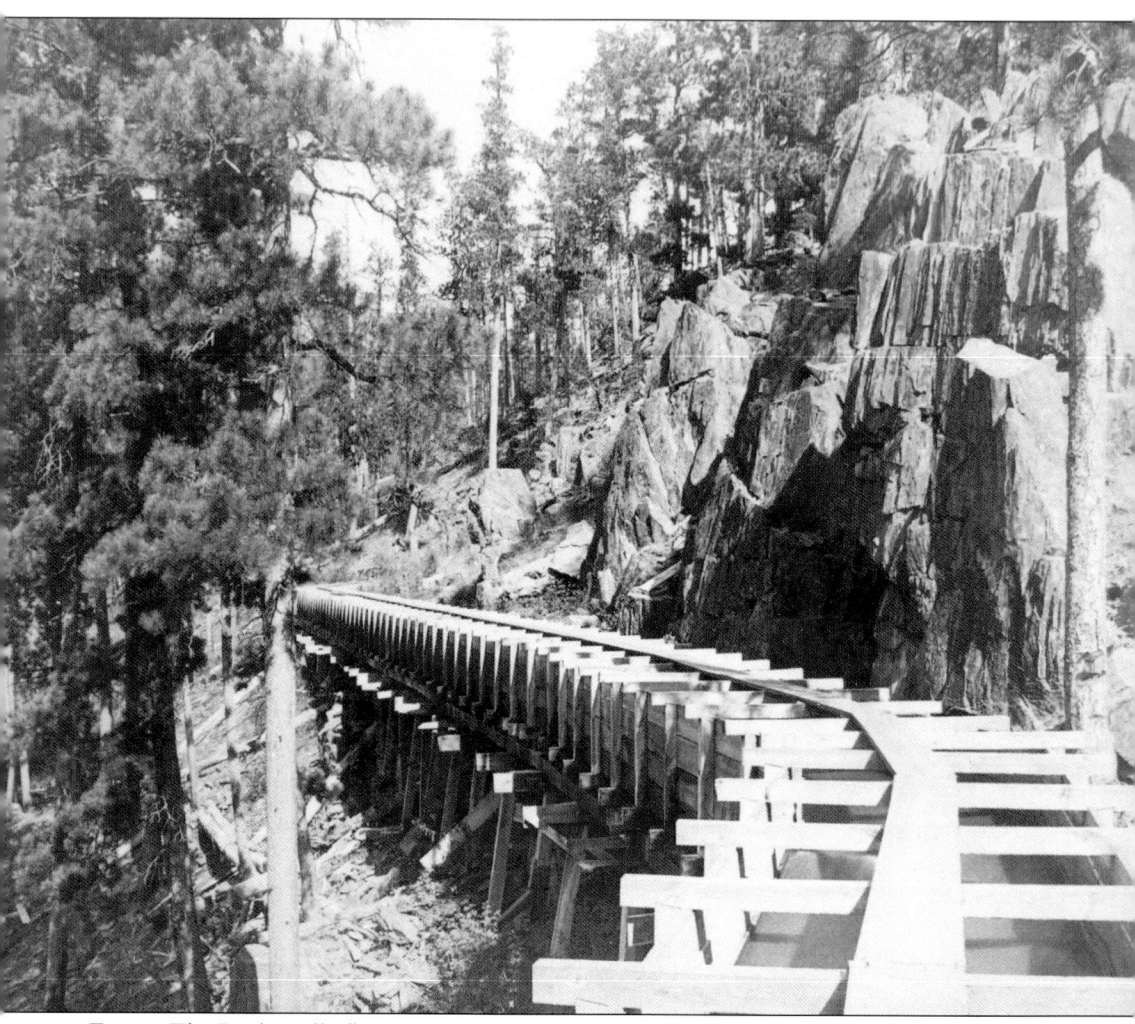

FLUME. The Rockerville flume would have appeared similar in construction to the one pictured. The July 14, 1880, *Daily News* reported, "In consequence of the Capt. West crookedness there was no money to pay off the laborers on the Rockerville flume at the last pay day, and thinking that one month was as much as they could afford to lose they all quit, and since then have been waiting around to see what might turn up. We learn that this difficulty has been arranged . . . as the money is already to pay for all the labor that may be required to finish the work. . . . The money will be disbursed through the company's agent. Major Bierce and the money, $35,000 is here in bank to do it with." The following week, the paper stated that the day previous, the West trial had lasted all day and that West had claimed to be "too nervous to be present," but his request to be excused from the proceedings was denied by the courts, after which, "he came in and laid on a bench." The Rockerville flume's ownership changed several times. The flume deteriorated due to irregular use, but not before it had enabled $20 million worth of gold to be mined. Eventually, Capt. West was required to return the company's property and pay $10,000 in cash.

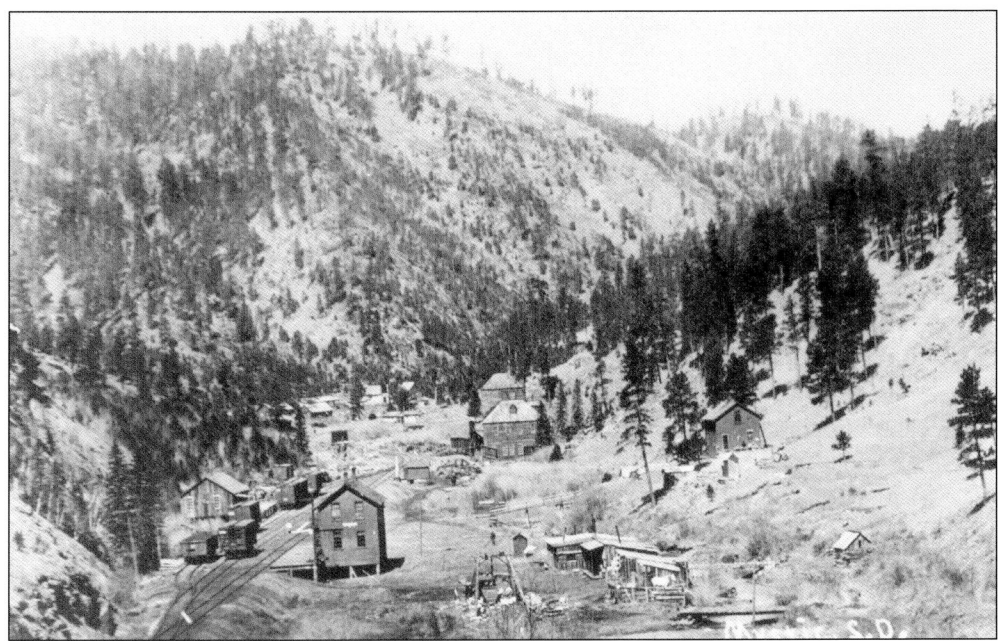

MYSTIC, 1916. Situated in a picturesque valley, Mystic was near the junction of the Rapid City, Black Hills, and Western Railroad and the Chicago, Burlington, and Quincy Railroad. It began as a mining town, and its founders hoped Mystic would become a railway center. Pictured is the Mystic train depot from a distance. A Rapid Canyon line train also known as the Crouch Line is on the left branch. The last passenger train stopped at Mystic in July 1947, and the last freight train went through in 1983. George Frink's sawmill sustained the small town until 1952 when the sawmill closed, signaling the end of Mystic.

CROUCH LINE. The 30-mile-long railway from Rapid City to Mystic was affectionately known as the Crouch Line. The line was unique in that it made 14 complete circles on every trip to Mystic. Some 110 bridges spanned the line, 4 for every mile. In 1907, flood waters demolished all but five bridges, but they were rebuilt, and the line continued. The Crouch Line was known by at least 10 different names, including the Dakota and Wyoming Railroad; Dakota, Western, and Missouri Railroad; the Rapid Canyon; and the Rapid City, Black Hills, and Western. Nonetheless, everyone referred to it as the Crouch Line, named for Charles D. Crouch, a contractor on the railroad.

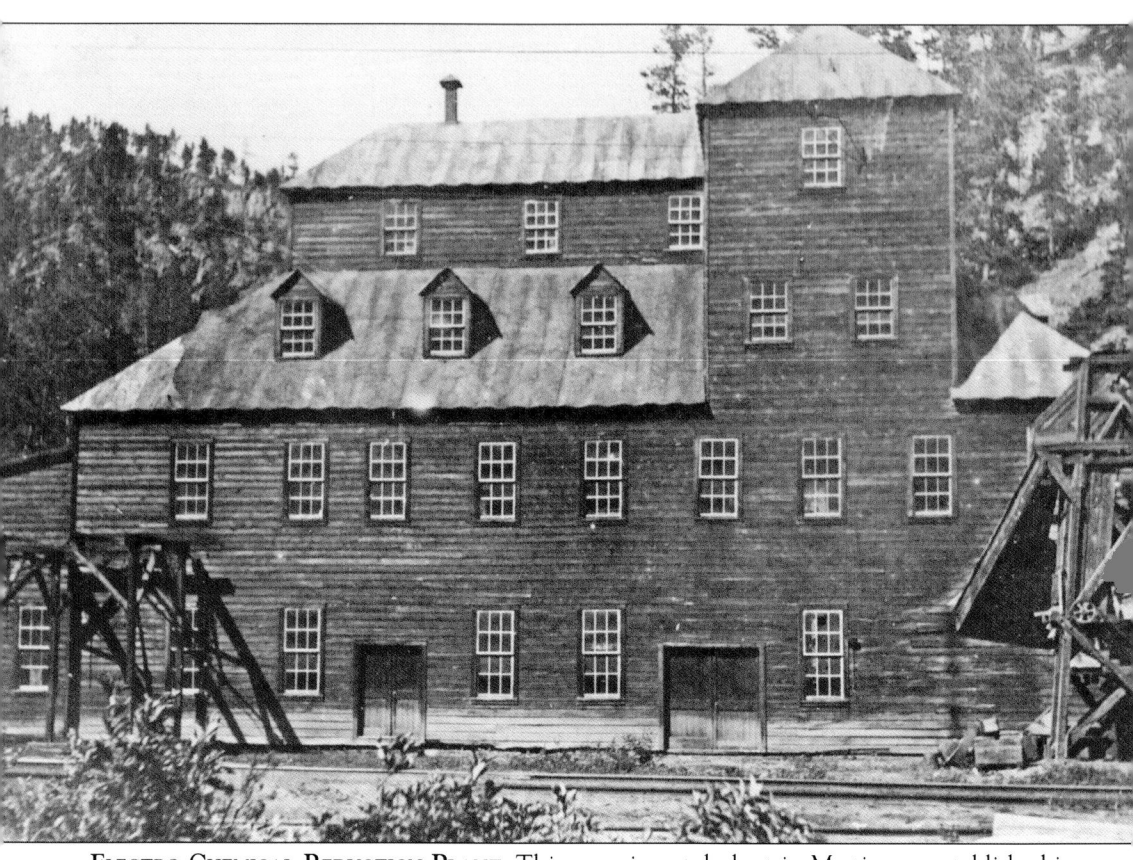

ELECTRO-CHEMICAL REDUCTION PLANT. This experimental plant in Mystic was established in 1902–1904 to extract gold using an advanced chlorination process. Mining engineer F. H. Long built the plant, A. M. Leedy became the master mechanic, and George Gleason was hired as chemist. The experiment worked fine in the laboratory, but unfortunately, the million-dollar enterprise was a failure when the sand would not suspend in solution, instead settling and solidifying in the tanks. The mill was abandoned in 1907.

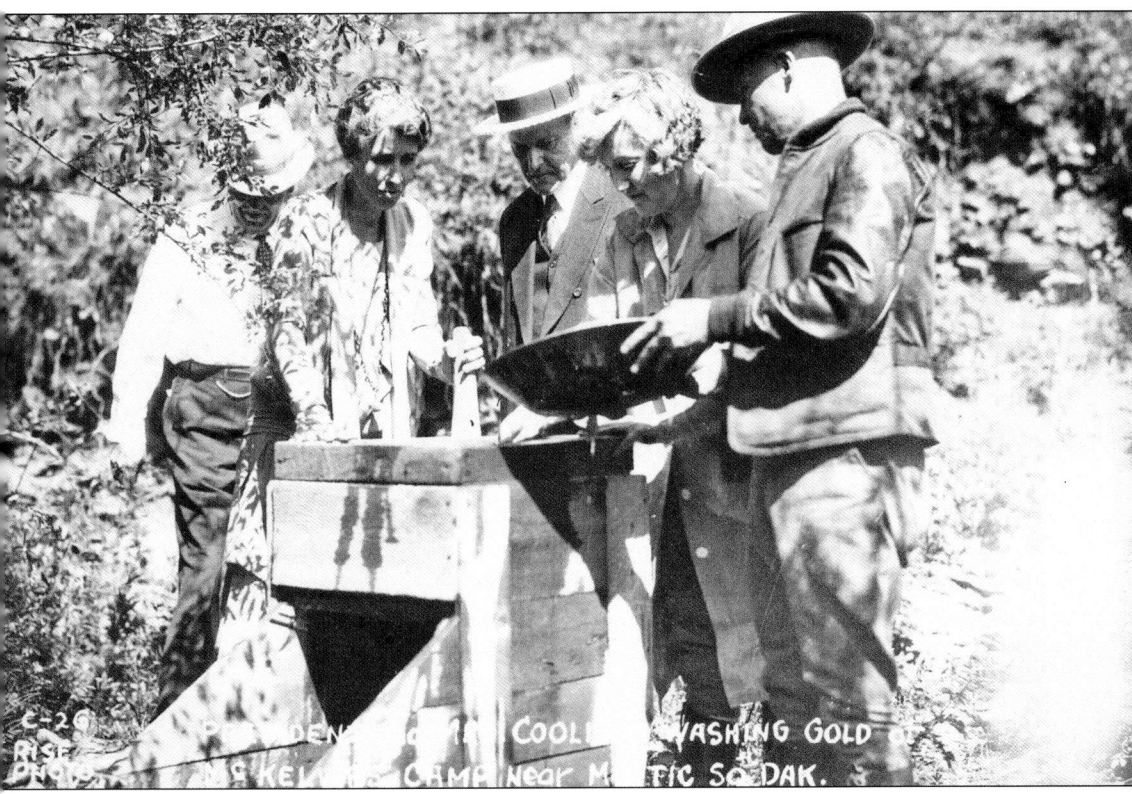

PRES. CALVIN COOLIDGE AND FIRST LADY GRACE COOLIDGE. Pres. Calvin Coolidge and First Lady Grace Coolidge spent the summer of 1927 in the Black Hills. While there, they resided at the State Game Lodge in Custer Park, which would become known as the Summer White House. The president and his wife enjoyed many excursions in the area. One of them produced this image of the Coolidges washing gold near Mystic. Since every event in which they participated received national and international attention, their stay in the Black Hills raised awareness of the region as a vacation spot and, along with the carving of Mount Rushmore, helped to boost tourism in South Dakota. A second president stayed at the State Game Lodge. In 1953, Dwight D. Eisenhower spent three days there when he came to the Black Hills to dedicate Ellsworth Air Force Base in Rapid City. Also, on occasion, Teddy Roosevelt visited the Black Hills, prior to his presidency. He is known to have been in Deadwood in 1892 and 1900.

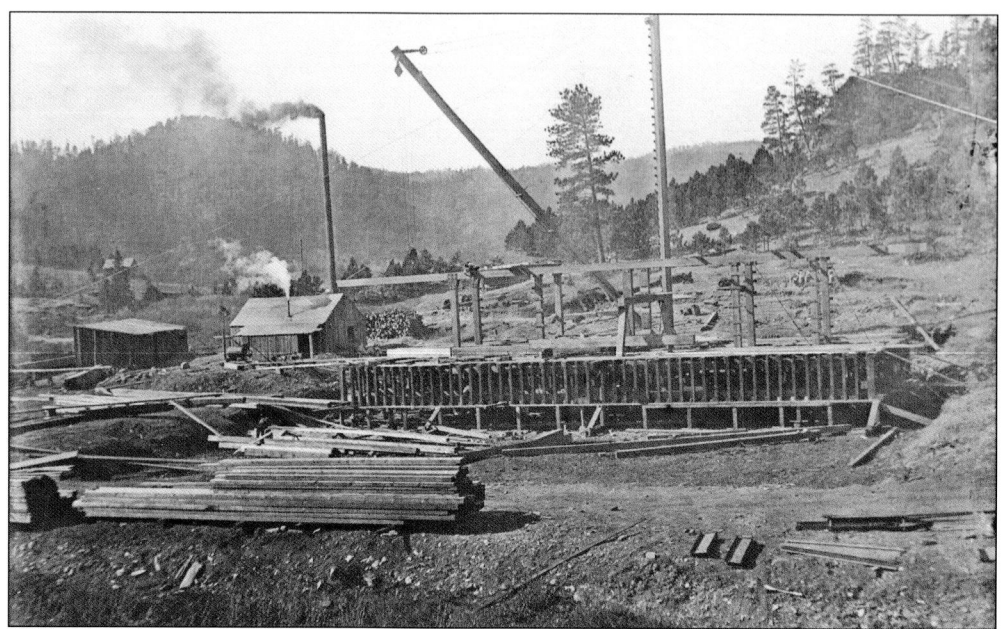

BUILDING THE EVAN'S DREDGE. In 1910, the Evans family of Denver financed the Castle Creek Hydraulic Gold Mining Company's building of the largest bucket line dredging operation in the Black Hills. The dredge operated near Castleton where miners had found rich streaks of gold. Every day, 78 buckets stirred the stream, searching the gravel for gold. The railroad brought in coal for a steam-generating plant located nearby to produce electricity to operate the dredge mechanism. Despite the rich pockets, the ore laid 25 feet deep, and the gold the dredge uncovered was considered to be too low-grade to continue. The dredge was moved to Oregon and then eventually sold overseas. (Courtesy Black Hills Mining Museum and the Minnilusa Historical Association.)

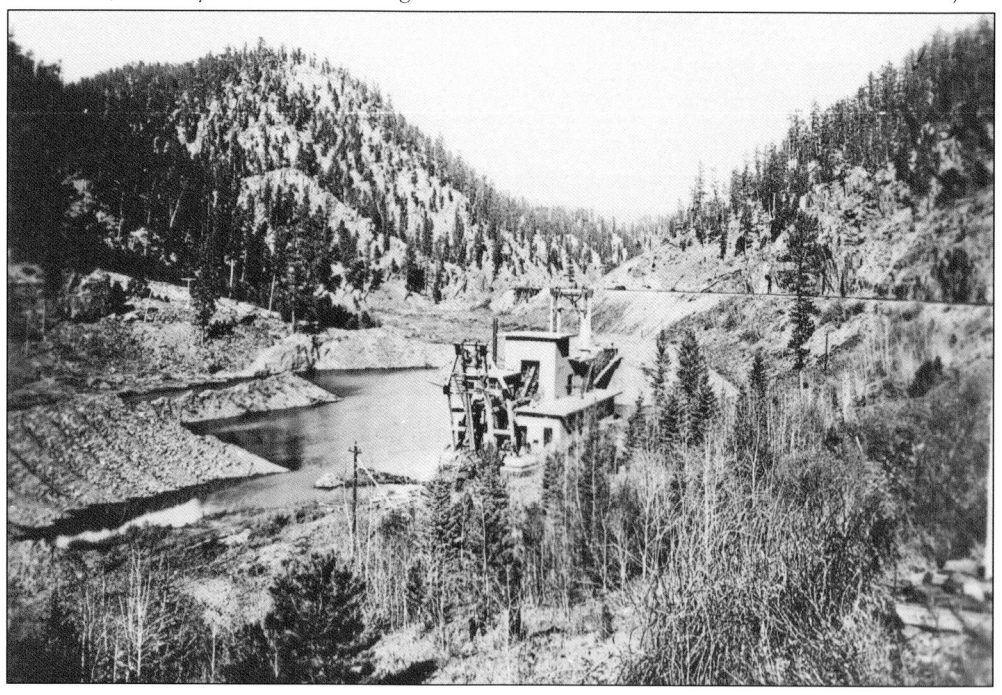

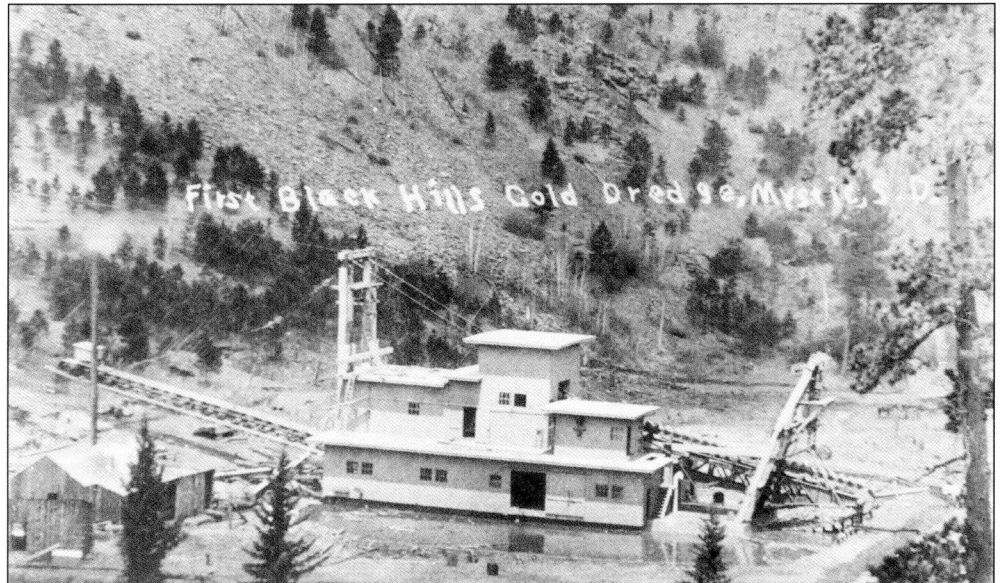

EVAN'S DREDGE. This dredge was mounted on a barge as it moved along, creating its own pool. It heaped up piles of washed rock behind it, creating great windows of coarse rock that can still be seen today near the Castleton site. The barge was left, and the ribs of it are somewhat exposed in the pool, which has been overgrown with grass and reclaimed by silt. (Courtesy Black Hills Mining Museum.)

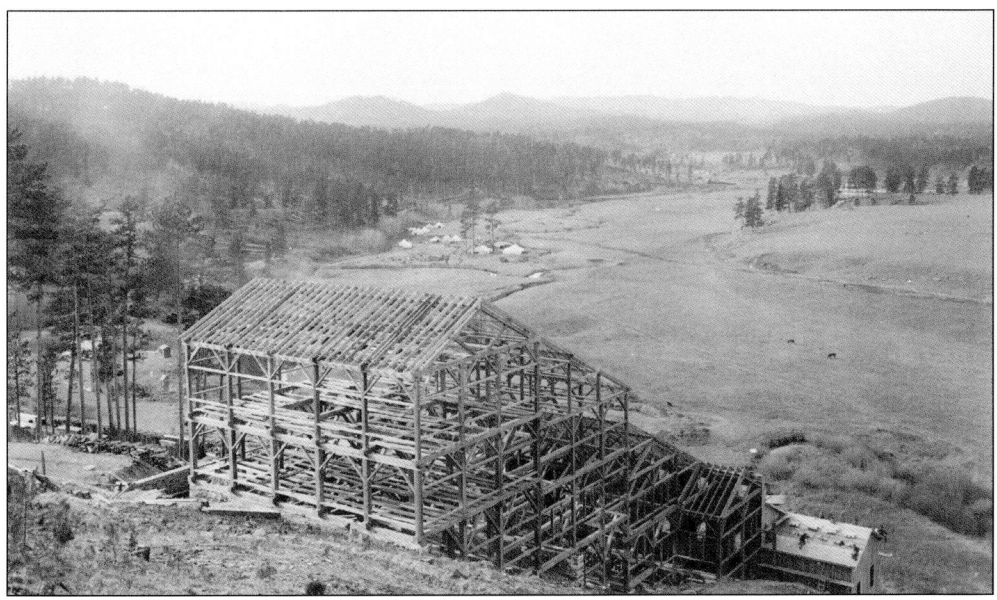

MYERSVILLE. Named for miner and lumberman John Myers, the town of Myersville was home to 150 residents in 1883. The Alta Lodi Mining Company built a 40-stamp mill, but not enough ore was found to keep it running. It was moved to Lookout on Castle Creek. James Cochran worked five claims in 1892 using a 16-ton Huntington Mill. In the 1930s, when prospecting became appealing again, a few more mining ventures resumed.

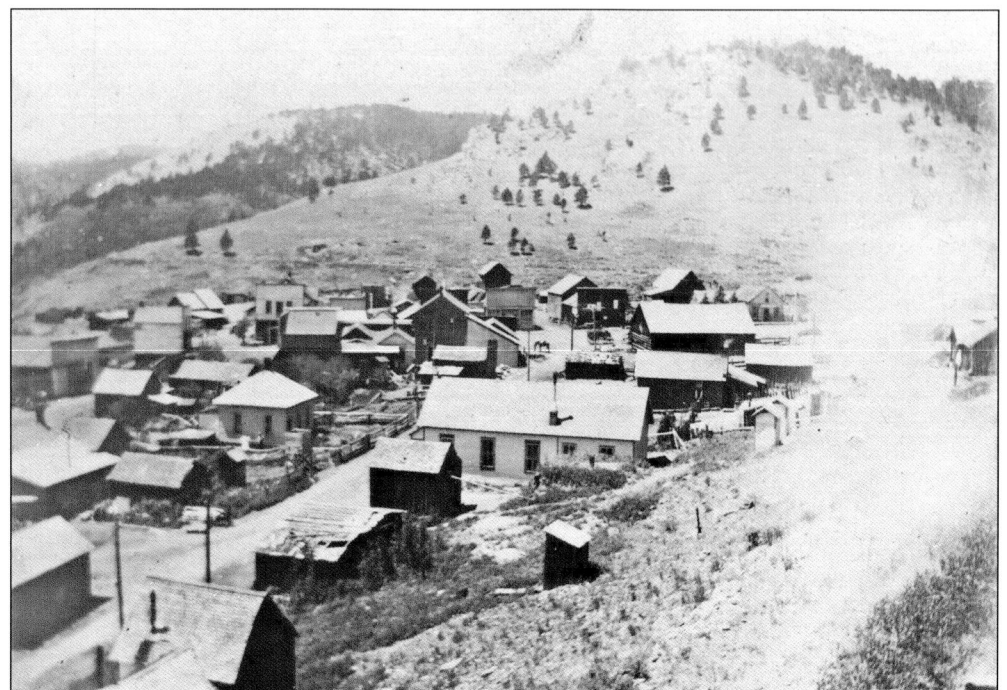

ROCHFORD. Founded in 1877, Rochford boasted a population of 500 by 1878. As in most Black Hills early towns, mining booms created fluctuations in the population. In 1881, for instance, the *Black Hills Daily Times* reported that Rochford was a deserted village and that the "population during a visit there consisted of three men: a saloon keeper, the postmaster and a sad eyed prospector." The once-booming town dwindled in size by 1900 to 48 inhabitants. Today Rochford is practically a ghost town and maintains a rustic appeal that attracts sightseers.

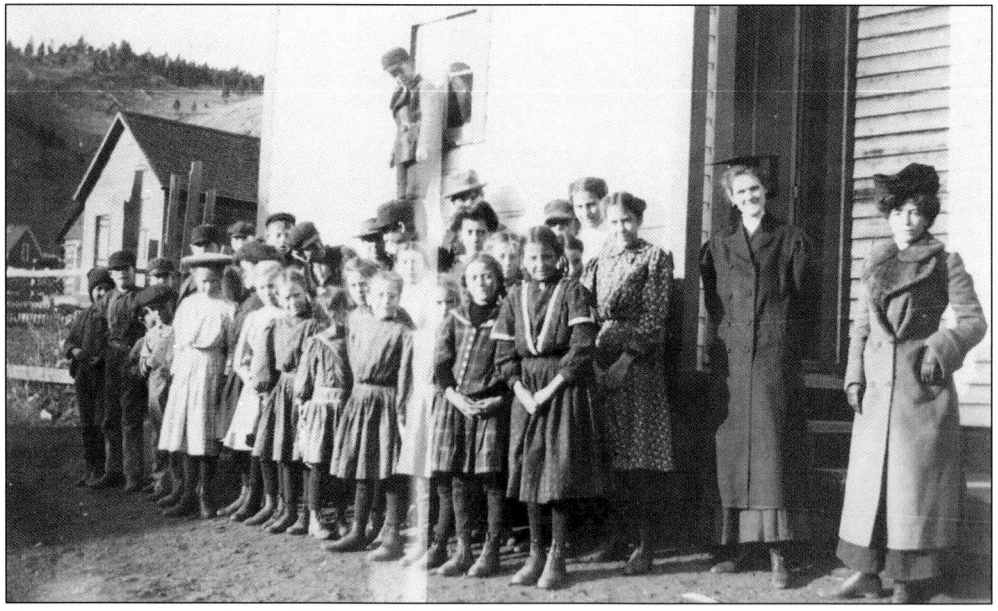

ROCHFORD SCHOOL. Annie Tallent, a Black Hills pioneer, was not only postmistress in Rochford but taught in Rochford, too—as well as in other Black Hills towns.

RICHARD HUGHES. The *Black Hills Daily Times* of April 27, 1879, states that Dick Hughes and Mike Rochford "came to the hills in the spring of 1876 and owned an interest in the big bonanza mines of the Lead Belt, however they sold that interest for a 'song.'" The *Times* opined that if they would have kept it, Hughes and Rochford would be millionaires. Hughes and Rochford were the original discovers of Rochford, named in honor of Mike Rochford. Not only did Hughes have interest in the mining boom, but he began his newspaper career as a typesetter and a reporter, and later became the first editor of the *Rapid City Daily Journal*. As a distinguished Black Hills pioneer, he later wrote a book on his experiences in the hills.

HOME OF O. P. OLSON, 1901. In front of the Olson home are, from left to right, Mrs. Dority, Gussie Happ, Mrs. Palmer, Frances Travers (Haven), Alice and Edna Dority, Harold Heath, and Edwin Dority. O. P. Olson stands by the gate directly in front of his home.

ROCHFORD HOTEL. This 1885 Rochford hotel was owned by E. E. Shepherd and his wife. By 1885, Rochford was experiencing another boom. The Standby Mine was producing up to expectations, and numerous other area mines were paying as well. Rochford ultimately became the center of the most-productive and richest mines on Rapid Creek.

STANDBY MILL. George Riley Boardshear and two brothers-in-law, Peter and John VanDorn, built the mill in 1879 and 1880. The equipment for the mill was shipped to Rochford by wagon from Bismarck. The *Black Hills Daily Times* of June 28, 1881, noted the inactivity of the Standby Mill, calling it, "a stale, flat unprofitable piece of property, which is a grievous sight to behold to those who regard the prosperity of the country." The rock that the mill had been working did not pay, so it shut down. By 1884, however, the story was different. The newspaper reported that the Standby had been running on good ore. They were delivering ore from six different places and as they worked farther into the mine it showed an immense body of ore. The Standby Mill was running at full capacity, with all of its 60 stamps in operation, for the first time in three years. The mill was rebuilt in the 1930s and continued operation until 1942. Because of its dangerously deteriorating condition, the picturesque mill was torn down in 1987.

MONTANA MINE. Charles Dunphy discovered the Montana Mine located north of Rochford in 1879. George G. Smith and other members of the Gregory Gold Mining Company built a 40-stamp mill, but the amalgamation method did not remove the gold from the ore. The mine was reopened in 1901 and again in 1938, but it was not successful. (Photograph by John Grabill; courtesy Library of Congress Prints and Photographs Division, LC-USZ62-11784.)

SINKING A SHAFT. These two miners are sinking a shaft to reach gold-bearing ore, using the aid of a collar and hand windlass. Logs were used to support the shaft and prevent cave-ins. Sometimes a pump was used to draw the water out of the shaft; sometimes miners employed a Chinese pump (with attached tin cups) to carry the water up and out of the mine.

Three

BEAR GULCH, TINTON, AND CARBONATE

EARLY TINTON. The newspapers in 1878 reported a stampede from Deadwood to the Bear and African Gulches. Among those stampeding were experienced Montana sharps and quite a number of tenderfeet. As a result of that rush to find gold, several settlements sprang up near Bear and African Gulches. Bear City was established in 1878. It was composed of miner cabins, stores, a hotel, a saloon, and a post office located at the mouth of African Gulch, where it entered Bear Gulch. In Potato Gulch, the cluster of cabins there was known as Nugget City. Forrest City, located at the head of African Gulch at the top of Negro Hill, later became the town of Tinton. Cabins, a post office, boardinghouse, stores, and saloons comprised this settlement. (Courtesy Black Hills Mining Museum, Lead.)

BEAR GULCH. With much of the area completely staked, placer mining began in earnest in 1876. Iron Creek, Spotted Tail Gulch, Shirt Tail Gulch, Centennial Gulch, Bonanza Gulch, and Mallory Gulch produced large amounts of placer gold. Since the gold was of a coarse nature, many nuggets were found. The Big Hill Consolidated Gold Mining and Reduction Company was organized in 1903. A group of Spearfish men, the principal stockholders, owned 260 acres on Bear Gulch. In all, several different mining companies owned hundreds of acres of mining ground. (Courtesy State Archives of the South Dakota State Historical Society.)

THE TINTON COMPANY

Producers of American Tin

Mines and Reduction Works, Tinton, Lawrence County, South Dakota, U. S. A.
Offices, Tinton, South Dakota, and 145 Van Buren Street, Chicago, Illinois.

P. B. WEARE, Vice President. E. W. NOAKES, Secretary and Treasurer.
CHAS. WAITE, General Manager.

TINTON NEWSPAPER ADVERTISEMENT. Placer tin was discovered in 1876, and a tin strike in 1884 turned attention to tin. The American Tin Mining Company organized first in 1886. The Tinton Tin Mining Company then organized in 1902–1904 and built a cooperative town with houses for the employees, stores, a hotel, bank, newspaper office, and saloons. By the end of 1904, eighty-thousand pounds of tin concentrate had been shipped from Tinton to Wales, England, for refining. (Courtesy Leland D. Case Library, BHSU.)

Tinton. Several different corporations have run Tinton's mining (and the town itself) over the years. In 1927, the Black Hills Tin Company gained control of the Tin Reduction Company, which included 2,700 acres. The Dakota Tin and Gold Company had organized as late as the 1930s and owned the mines and town. In 1941, the Black Hills Tin Company reorganized to recover spodumene and tantalite deposits needed for the war effort. The company built a new mill, using a flotation method to separate the spodumene from the quartz and remove the tantalite. A fire burned the mill to the ground, but a new mill was built and processed about 100 tons per month. It closed after the end of World War II. (Courtesy Black Hills Mining Museum, Lead.)

TINTON CELEBRATION. Dressed in their finery and obviously proud of their town, Tinton's citizens are probably celebrating the Fourth of July. A man with a fiddle stands on the platform, contributing to the festive event. Tinton was a well-planned town, with its buildings constructed in a circle around Roosevelt Park, named for Teddy Roosevelt's son Kermit, who had visited there. Today Tinton is the largest ghost town in the Black Hills area. Its mines originally covered land in six or seven sections, extending over the Wyoming border. (Courtesy Black Hills Mining Museum, Lead.)

TINTON, COMPANY TOWN. Tinton Tin Mining Company built the cooperative town of Tinton, and in 1903, it held its first Fourth of July celebration. The *Tinton Times* wrote up the event: "The camp was in ship-shape order The buildings were suitably decorated with bunting and flags . . . the new store building just completed was bedecked with flowers, tiger lilies, evergreens and ferns . . . overlooking the surrounding country for miles [Tinton] has numerous advantages, aside from beauty over the average mining town, which causes wonder that more of them are not placed up out of the gulches." (Courtesy State Archives of the South Dakota State Historical Society.)

TINTON IN THE 1920S AND 1930S. John Blank managed the Black Hills Tin Company in 1927. The old mill was torn down and a new 300-ton mill took its place. Blank modernized the town by installing electricity and running water. Eleven teams of horses brought the giant diesel up the steep, winding road from Iron Creek to Tinton to generate electricity. He even built a gymnasium and a tennis court for the town people to enjoy.

SAM SCOTT'S TIN MINE. Sam Scott, a founder of Rapid City and a mining companion of Richard Hughes, had interests in mining—as did most everyone in the area. In 1887, the Black Hills region was optimistic concerning the discovery of tin. Some even thought that the tin mines of the Black Hills were the most important mineral discovery made in the United States since the discovery of gold in California in 1849. In addition to the Tinton area, the Etta Mine, 3 miles from Harney City, and ledges near Hill City were rich with tin.

BEAVER CREEK. East of Tinton, Beaver Creek was surrounded by streams that yielded large gold nuggets. About 20 gold nuggets were recorded found in the area between 1875 and 1931. An 1879 *Times* article mentioned Beaver Creek as being a solution to finding the water to work the claims: "Our informant believes there is almost a township of land covered by these high placers and which will eventually yield bountifully under the pressure of the hydraulics. It is generally believed that plenty of water can be brought to claims from Beaver Creek, some 15 miles distant."

POTATO CREEK JOHNNY. The diminutive 4-foot, 3-inch-tall Johnny Perrett, known as "Potato Creek Johnny," became famous by discovering one of the largest gold nuggets found in the Black Hills, near Potato Creek. Besides being a prospector, Johnny played the fiddle for dances, showed the tourists how to pan for gold, and participated in the Days of '76 parade. He lived in a cabin near Nugget City, prospected from 1891 into the 1930s, and became a well-known Black Hills character. (Courtesy Leland D. Case Library, BHSU.)

JOHN PERRETT AND HIS GOLD NUGGET. In 1929 and again in 1931, John E. Perrett discovered nuggets that have made mining history. The first nugget, found in 1929, was 5 inches long and weighed 7.5 ounces. It was the largest found on Potato Creek and one of the largest found in the Black Hills. In 1931, he discovered a 3-ounce, 17-pennyweight nugget and another weighing 1 ounce, 19 pennyweights. John Perrett sold the 5-inch nugget to W. E. Adams. In this photograph, Potato Creek Johnny is holding the original nugget. A replica of the nugget is displayed at the Adams Museum in Deadwood. (Courtesy Black Hills Mining Museum, Lead.)

CARBONATE CAMP. James Ridpath discovered silver-bearing ore in the autumn of 1881. The Carbonate Mining District formed and founded a town named West Virginia. By 1881, there were over 200 men working in the area. In 1886, the rich discovery of the Iron Hill caused many miners to stampede to the area. By now, the town was known as Carbonate, and the Iron Hill Company constructed a 60-ton smelter. Built in 1889 and dismantled in 1900, the William Hugginson Black Hills Hotel, pictured on the right, was advertised as the largest in the territory. (Courtesy State Archives of the South Dakota State Historical Society.)

JOHNNY SNOW'S CABIN, CARBONATE. In 1901, W. B. Johnson photographed John Adams and Johnny Snow while they were tipping refreshments in Carbonate. John "Shorty" Adams was 40 years old at the time; Johnny Snow died two months after this picture was taken. Perhaps they knew Carbonate was fading away and lifted a toast to the good old days. (Courtesy State Archives of the South Dakota State Historical Society.)

CARBONATE MINERS. Isaac Forest bought the lot by the two large trees at left. He established a combination store and cabin on this site. Over time, the rich deposits disappeared, and the operation slowed down. By 1884, the newspaper reported the discovery of a rich body of ore on the north fork of Squaw Creek, and the Iron Hill resumed work. In 1887, the mine, with its 50- to 60-ton daily capacity smelter, was producing $3,000 per day, but by 1891, it was reported that little work had been done that year at the Iron Hill. The Iron Hill continued operation into the early 1900s under several changes of management, and then the mines closed and the town gradually disappeared. (Courtesy Black Hills Mining Museum, Lead.)

CARBONATE STREET SCENE. In its prime, Carbonate was a busy place. The Iron Hill was the largest mine near Carbonate, but there were others as well. The Spanish R, the Seabury-Calkins, the Black Nell, and the Union Hill produced silver, too. No less than 16 mine whistles blew daily. There were numerous saloons, laundries, a bank, a newspaper, a school, a bakery (pictured), boardinghouses, and red light districts. In spite of the town's success, arsenic fumes killed the cats and caused respiratory problems. Diphtheria, scarlet fever, and mining accidents brought their share of sadness to town residents. (Courtesy Black Hills Mining Museum, Lead.)

MINING CERTIFICATES. Notice Seth Bullock's signature on the original mining certificates pictured. Although mostly known as a Deadwood entrepreneur, lawman, and friend of Teddy Roosevelt, Seth Bullock was active in mining interests in both the Galena Mining District and in the Carbonate District. In the 1880s, he held offices or sat on the board of directors for various mines. He organized the Eureka Mining Company in 1881, was on the board for the Rattler-Gilroy Consolidated Mining Company, and served as president of the Carbonate District in 1885. The next year, he was named president of the Iron Hill and director and president for the U. S. Grant Mining Company. In 1887, he was also president of the Big Hill Mining Company, organizer and eventually president of the Deadwood Gold and Silver Mining Company, director for the Darboy Mining Company, president of the Bi-Metallic Mining Company, director and president for the Treasure Coach Mining Company, and treasurer of the Endymion Mining Company. He was president of Brookline Mining Company and the Iron Hill in 1887 and served as president of the Hestor A. in 1891.

CLEOPATRA MINE. Early claims were staked in the 1880s. The Cleopatra Mining Company was incorporated and funded by a Huron syndicate in 1898. The mining property was difficult and expensive to develop because of the precipitous terrain. Roads washed out and repairs were expensive. The Cleopatra Mine officers visited Mercur, Utah, where a mill operated by treating ores with a cyanide solution. Upon returning, the officers modeled the Cleopatra after this mill. In 1900 and 1901, a 50-ton cyanide plant was built running uphill, powered by steam at a cost of $30,000. It ran for 15 months, and in that time $30,000 in gold was recovered. The mill did not yield a profit, however, so was shut down. The mine was reactivated several times but finally closed for good in 1926. Pack animals hauled some of the ore over wagon roads to the railroad lines to be shipped for processing. The remains of the Cleopatra stood for years, unwilling to give up its hold on the mountainside. Artists and photographers documented its final days in paintings and photographs. (Courtesy Minnilusa Historical Association and the Black Hills Mining Museum, Lead.)

RESTAURANT. The Miners Exchange Restaurant was typical of eating establishments in gold country. The local newspapers printed their advertisements, advertising fresh fish and chicken, all the delicacies of the season, gastronomic luxuries, fancy steaks that could be had any style, and boiled dinners as a specialty. Some eateries promised to be open any hour of the day or night. Others boasted of feeding 200–300 customers a day. Since there were so many eating places in the area, the competing restaurateurs agreed that they would not sell meals for less than 75¢.

DEER HUNTERS. Many miners lived on wild game when it could be found, and some furnished meat for the area's eating establishments. One restaurant assured the public that its hunters were out hunting wild game. Before the railroad arrived, Black Hills residents depended on the freighting companies to haul in food with their ox teams, and food shortages were not unknown.

52

MINERS AND CABIN. The first miners lived in tents, brush shacks, wagons, or log cabins—whatever it took to show possession of, and hold title to, the claim. In this image, miners bring rock out of the mine in an ore car, which ran on wooden rails covered with strap-iron strips. In the left foreground is a platform box used to sort the ore. These miners are dressed in their best, obviously proud of their humble cabins and their claims.

THE FREEMONT, ELKHORN, AND MISSOURI VALLEY RAILROAD AND ORE TRAIN. On September 17, 1891, the *Black Hills Daily Times* reported that 22 cars of ore from Black Hills mines were on their way to Omaha, having left Chadron the previous day. The 400 tons of ore were carried to Chadron by several trains via Deadwood and Whitewood. The worth of the ore was estimated at $22,000. Streamers decorated the cars and bore the legend "Deadwood to Omaha," as well as the name of the mine and its location on the Freemont, Elkhorn, and Missouri Valley Railroad line. The following mines each contributed a car of ore en route: the Stewart, Golden Reward, Isadorah, Ross-Hannibal, Calumet, Retriever, Boscobel, Tony, Lundt, Mark Twain, Tornado, Double Standard, Portland, Boxton, Bonanza, Hardscrabble, Welcome, Empire, Trojan, Clinton, Harmony, Elk Mountain, and Iron Hill. All of the mines were located in the Bald Mountain and Ruby District except for the Iron Hill at Carbonate and Elk Mountain at Elk Mountain. The mine owners and superintendents met the train in Omaha. The details of this noteworthy event were telegraphed to newspapers throughout the United States in hopes of promoting the Black Hills region. (Courtesy Leland D. Case Library, BHSU.)

Four
RAPID CREEK, PLACERVILLE, AND ROBAIX

BIG BEND. Located on Rapid Creek 8 miles west of Rapid City was a productive placer area known as Big Bend. The nearly 50-mile Rapid Creek contained large amounts of gold-bearing gravel, and claims were taken all up and down the creek. The worth of each claim was valued at $50,000. Miners used hydraulic mining methods for the high bench gravels, necessitating the construction of a flume to bring in water to power the hydraulic hoses, called monitors or cannons.

BUILDING THE FLUME. Several companies attempted building the flume needed to bring water to the placer claims. The Rapid Creek and Manufacturing Company erected a sawmill to provide lumber for the flume and hired men to build it. They had constructed 3 miles of flume when they ran out of money. In 1880, Estella Del Norte Company began construction of a flume on Swede Bar as well as a flume above Pactola. Both projects were expensive and eventually abandoned.

FLUME OVER RAPID CREEK. A miner, L. A. Richards, worked the Swede and Placerville gravel bars. In order to bring water to his claim, he constructed a diversion dam at Pactola and built a flume to carry the water. Later the flume was extended successfully to Big Bend to run a generating plant at Powerhouse Gulch.

FLUME BETWEEN PLACERVILLE AND BIG BEND. The Dakota Power Company used the flumes and water rights abandoned by earlier mining ventures along Rapid Creek to generate electricity. In 1910, Dakota Power Company received a 20-year franchise to serve Rapid City. The 7-mile flume was completed around 1912 and brought water from Pactola to Placerville and Big Bend. Part of the flume was of box construction, and the other segment was round and made of barrel staves with steel bands around it. The drop of about 160–180 feet was made of steel. The power company built a steam generation plant and hydroelectric plant at Big Bend to furnish electricity. After a time, the plants were abandoned due to diminishing water supply.

PLACERVILLE. Located near Pactola, the Placerville gravel bar was a very productive bar on Rapid Creek. The man-made Pactola Lake has inundated many of the old diggings, including the town of Pactola. During the Great Depression of the 1930s, small-time miners reworked the diggings and made a good living while doing so. Currently the Placerville area is a church camp.

RAPID CITY CHLORINATION PLANT. The Black Hills Mining and Smelting Company established the chlorination plant in 1890. The plant cost $125,000, and ore was treated from the Welcome Mine near Deadwood. The venture was unprofitable, and after the plant was idle for a few years, a Colorado company purchased it and added a smelter. The National Smelting Company plant stood on Smelter Hill south of the South Dakota School of Mines campus in Rapid City and operated in 1902. The distance from the mines to the smelter and the high operating costs resulted in its closure.

ROUBAIX AND THE UNCLE SAM MINE. The Uncle Sam Mine was discovered in 1878 and was the only productive mine on Elk Creek. The coarse gold was mined to a depth of 650 feet. French cattleman and mine owner Pierre Wilbeaux bought the Uncle Sam in 1889 and renamed it the Clover Leaf. The mine closed down in the early 1900s, but it was explored again from 1934 to 1937. Very little remaining gold was found, however.

Roubaix. Pierre Wilbeaux also changed the name of the surrounding town from Perry to Roubaix after his hometown in France. In 1905, water flooded the mine to the seventh level; when the water could not be pumped because of a cave-in, it was abandoned. The Anaconda Company acquired the property in 1934 and drained the mine, but they eventually abandoned it as well. In 1899, five-hundred people lived in Roubaix, but today it is regarded as a ghost town. (Courtesy Leland D. Case Library, BHSU.)

Five

GALENA

GALENA'S UPPER END. On Bear Butte Creek southeast of Deadwood is the town of Galena, named for the vein of lead ore found in the area. Galena ore was of interest because of its silver content. According to Mildred Fielder in her book *Silver is the Fortune*, the origins of the community are a source of debate. Some mark Galena's beginning with the founding of the Sitting Bull Mine in 1875; others put the date in 1876. Regardless, by 1877 the town was flourishing. By January of that year, the town was home to approximately 400 miners and 75 houses. By mid-year, three smelters were in full operation. This view shows the upper end of town, from the middle point facing west. (Photograph by W. R. Cross; courtesy Leland D. Case Library, BHSU.)

School Hill. Prior to the construction of a permanent school, Nettie Wynn held classes in a temporary location up Ruby Gulch. The Galena School House shown here was built in 1882 and operated until 1942. It has been preserved as an historic site and is the starting point for the Galena Historical Society's annual fund-raiser—Galena Walk. Participants get to tread in the footsteps of those long-ago residents and visit points along the way featuring historic photographs or history interpreters, enabling them to feel what life was like in Galena back in the 1800s. Other features of School Hill were C. B. Harris's residence and assay office. This photograph was taken before 1900. (Courtesy Fred Borsch Collection.)

St. Basil's Catholic Church. Early Galena was home to two churches. St. Basil's Catholic Church, shown here, was built in 1883 by Father Rosen. Rosen came to the hills in 1882 and served as pastor of St. Ambrose in Deadwood as well as ministering in Galena until 1886, when he was transferred to Sturgis, South Dakota. The Methodist Church was built on the hillside overlooking the Corner Saloon. It employed no permanent minister; the church welcomed passing circuit riders to the pulpit. The building often served as an entertainment venue, with town dances often held in the church basement. (Courtesy Fred Borsch Collection.)

SUDDEN DEATH SALOON. Among other businesses that flourished in mining towns were saloons. The Sudden Death Saloon, shown here in the early 1900s, served as John Case's grocery store during the 1800s. The first postmaster, Fayette Place, did not remain in Galena for long, so in 1880 Case established a post office in his store and served as the postmaster. From left to right, the men in front of the saloon are Mr. Robinson, Mr. LaFevre, John Gardner, Martin Thompson, Frank Reins, Mr. Spittler, Angelo Bosatte, Bumbing (Angelo's Dog), Red the Barber, Mr. Banigan, Pop Coyle, John Sheahan, Charlie Orleans, and Mr. McGillis. (Courtesy Fred Borsch Collection.)

CORNER SALOON. Another well-known establishment was the Corner Saloon. Situated at the pronounced curve in Main Street, an interesting feature of this building is that the facade curved to match the bend. The men are gathered here to view the White Steamer, driven by William Treber, with Walter Groshong as passenger. (Photograph by Groshong; courtesy Jeri Fahrni Collection.)

BORSCH BOARDINGHOUSE. A number of families settled in Galena and made their living providing services to the miners. This 1906 photograph shows the Borsch boardinghouse. Fred Borsch II was the son of a farmer from Sturgis, South Dakota. He married Elleanor (Ella) Dany and in 1888 settled in Galena and opened a saloon. In 1902, Ella Borsch purchased a boardinghouse from Mrs. Calhoun and operated it for many years. Mildred Fielder notes that the saloon and the boardinghouse "blended to become a resort establishment." Shown here in front of the boardinghouse are, from left to right, Jason and Mrs. Forde (in the wagon), Doctor McGlade and Harry Ford (horseback), Fred Borsch II, Ella Borsch, Verda Scoggin, Gertie Dany, and Lydia Bailey (on the bridge). Nels Shaw is seen on the bench in the background. Fred II and Ella had two sons (Fred III and Chester), who also played their part in the history of Galena. Their descendants are avid boosters of Galena today. (Courtesy Fred Borsch Collection.)

SARAH CAMPBELL GRAVE, VINEGAR HILL CEMETERY, 1944. Among the residents of Galena's Vinegar Hill Cemetery is Sarah Campbell, the first non–Native American woman to enter the Black Hills. According to Lilah Morton Pengra in her book *Sarah Campbell: The First White Woman in the Black Hills was African American*, Sarah was born in 1823 to Marianne, a slave in the household of Jean Baptiste Duchouquette. Possibly her father was Duchouquette himself. Marianne had been leased to Duchouquette from the widow of her previous owner Joseph Brazeau. In his will, Brazeau had stipulated that Marianne and her children would be freed upon the death of his widow. Based on the will, Sarah sued for and won her freedom in 1837. She first came to the Black Hills as a cook with the 1874 expedition of Gen. George Armstrong Custer. Commonly known as "Aunt Sally," Sarah returned to the Black Hills during the 1876 gold rush and was an early resident of Crook City. She then settled in Virginia City near Galena. In addition to domestic work and midwifery, she owned five silver mines. Sarah Campbell died in 1888. (Courtesy Thomas O'Dell Collection, BHSU.)

BRANCH MINT. Smelting and chlorination were the two ways in which to extract silver from the ore. Salt was necessary in the chlorination process, and thus the discovery of Salt Spring in Newcastle, Wyoming, was a fortunate event for silver mining in Galena. Here in the foreground is the Florence Mill, built by Robert Flormann and the Florence Mining and Smelting Company in 1878 or 1879. Flormann owned the Florence Mine, located a half a mile from Galena near the Sitting Bull Mine. Later the Florence Mill became part of the Branch Mint Mill seen in the background. (Courtesy Fred Borsch Collection.)

BRANCH MINT MILL, 1906. Mining activity in Galena waxed and waned over the years. In 1904, during the particularly optimistic days of the early 1900s, Jim Hardin completed the Branch Mint Mill. Hardin, Branch Mint's president and general manager, had grand plans for the mill, which included 180 stamps and an immense cyanide plant. His projected processing capacity was for 900 tons a day. The Branch Mint Mill did not realize its promise, and by 1912, it was in deep financial trouble. On February 5, 1913, the property was sold to Walter E. Graham of Philadelphia for $20,000. Here in this photograph, the Burlington Railroad tracks pass in front of the mine. (Courtesy Fred Borsch Collection.)

BRANCH MINT AND HOODOO MINE WORKMEN, 1906. In 1896, a consolidated mining group called Union Hill organized in Galena, in the Two Bit Creek headwaters area. By 1898, financial difficulties caused them to reorganize as the Galena Mining and Smelting Company. The company went into foreclosure in 1903 when Jim Hardin purchased the properties, creating the Branch Mint Milling Company. Two of the mines included were the Branch Mint and the Hoodoo Mines. From left to right are three members of the Ickes family (seated), four unidentified, Branch Mint president and general manager Jim Hardin (wearing a white shirt), unidentified, Nels Shaw, John Gardner, unidentified, Fred Borsch II, four unidentified, Shorty Sisk, and Fatty Sisk. (Courtesy Fred Borsch Collection.)

INTERIOR OF THE HOODOO MINE. The Hoodoo Mine was part of the extensive Branch Mint holdings and then part of the Union Hill group. The Hoodoo Mine became inactive in 1912. The two men on the left are Fatty Sisk (far left) and Charlie Sisk. The other men are unidentified. (Courtesy Minnilusa Historical Society.)

Natalie, 1906. Among the most fondly remembered former residents of Galena is Natalie, Jim Hardin's steam engine. Jim Hardin built the 3-mile, narrow-gauge railroad through Galena to connect his Hoodoo Mine and other holdings above Galena to his Branch Mint Mill below town. Hardin's rail line connected with the Deadwood Central Railroad, enabling him to ship ore from the Branch Mint Mill to Deadwood. For many years after the mine closed, Natalie resided quietly in her shed. Then, in 1953, she was purchased by the Wonderland Museum in Billings, Montana. In 1983, she returned to the Black Hills and since then has resided at the Crazy Horse Memorial in Custer. Seen here in 1906, she is crossing Terrible Gulch trestle on the lower end of Galena. (Courtesy Fred Borsch Collection.)

THE GILT EDGE MINE. The Gilt Edge Mine near Strawberry and Two Bit Creeks was one of several in the area west of Galena. Joe King founded the Gilt Edge in 1876. Off and on, the mine produced both gold and silver until at least 1941. Around 1900, the Gilt Edge was consolidated with an adjoining mine called the Dakota Maid to become the Gilt Edge Maid Mining Company. The years between 1905 and 1916 were particularly active. According to Mildred Fielder in *A Guide to Black Hills Ghost Towns*, production between 1900 and 1916 amounted to 37,486.16 ounces of gold and 20,536 ounces of silver. The mine became inactive in 1941.

ORE CARS. Miners relied on numerous ore cars to carry the ore from the mines to the mills. Some ore cars could contain a ton of rock and required enormous physical stamina. In the mines, animal power moved the cars at first, later to be replaced by small engines to pull the load. In the beginning, ore cars loaded with ore were hoisted to the surface and unloaded by workers. Later skips hoisted the ore to the surface and dumped it.

Six
DEADWOOD, UPPER DEADWOOD GULCH, AND BOBTAIL GULCH

DEADWOOD MAIN STREET, 1876. Named for the dead timber strewn along the gulch, Deadwood came into existence when prospectors discovered gold in the northern Black Hills. Deadwood boomed when placer claims were staked along the steep gulches. In a year's time, the placers were exhausted, but Deadwood remained the center of attention. A fire in 1879 destroyed the hastily constructed town, which signaled the end of the gold rush. Using brick and stone, Deadwood rebuilt and ushered in a new era of prosperity and fame. (Courtesy Black Hills Mining Museum, Lead.)

CYANIDE PROCESS, DEADWOOD. Deadwood built reduction plants to treat the refractory ore that came from the various mines in the Black Hills, which used a network of narrow-gauge railroads to reach the facilities. The reduction plants implemented several processes to separate the gold from the ore. These processes were mainly pyritic smelting, chlorination, and the cyanide process. The Golden Reward built the first plant in 1887, the Deadwood and Delaware Smelter built their first plant in 1889, and the Gold and Silver Extracting, Mining, and Milling Company was built to use the cyanide process. (Courtesy Leland D. Case Library, BHSU.)

DEADWOOD AND DELAWARE SMELTER, 1889. Refractory ores required special processes to remove their gold. Smelting attempted to melt the metal from the rock. Built in 1888, the Delaware smelter was later absorbed by the Golden Reward. It produced over $2 million a year in gold and silver matte. Matte acted as a collecting agent for precious metals and could be shipped to market in this concentrated form. (Photograph by John Grabill; courtesy Library of Congress Prints and Photographs Division, LC-USZ62-20147.)

DEADWOOD AND DELAWARE SMELTER. Joseph and William Swift of Wilmington, Delaware, owned the original plant, which burned to the ground in March 1898. It was rebuilt of steel. The August 8, 1891, *Black Hills Daily Times* reported after the fifth day's run of the Delaware Smelter that it was an "unqualified success" and was operating "as smoothly as could a sewing machine in perfect repair." Two carloads of matte were on hand and valued at $6,000. One carload would be shipped to Aurora, Illinois, for refining since the Omaha plant was closed down. (Courtesy Leland D. Case Library, BHSU.)

DEADWOOD REDUCTION WORKS, 1890. The reduction works contained a smelter, a stamp, and amalgamation works, several large cyanide plants, ore testing and sampling works, and the U.S. government assay office. Before the ores were treated, they were assayed to find out their value in gold, then analyzed in a laboratory to determine the degree of heat and length of time required to roast them and to determine the proper quantity of different chemicals required to insure good results. Various mines in the area brought their ore by rail to be treated. (Photograph by John Grabill; courtesy Library of Congress Prints and Photographs Division, LC-USZ 62-78502.)

CELEBRATION IN DEADWOOD, 1888. Deadwood celebrated the opening of the Deadwood Reduction Works. Soon, the largest cyanide plant in the U.S. would be located in the Black Hills, the Black Hills held third place in the ranks of gold-producing states and territories, the Homestake was the greatest gold mine in the world, and the mineral output of the Black Hills for 1902 would be close to $10 million. Indeed, the Black Hills were the richest 100 miles square on earth. (Photograph by John Grabill; courtesy Library of Congress Prints and Photographs Division, LC-USZ62-78540.)

DEADWOOD AREA MILLS AND PLANTS. Numerous ore reduction works existed in Deadwood and in the surrounding area. The cyanide process was introduced in the 1890s. As seen in this photograph, many plants were in operation. (Courtesy Black Hills Mining Museum, Lead.)

DEADWOOD. The Deadwood Mills were located in the first ward and were connected by a jumble of railroad spurs and trestles to the main line. The Deadwood and Delaware Smelter is in the center of the photograph spewing smoke.

DEADWOOD MAIN STREET. By 1903, Deadwood was shedding its image of a mining town and becoming the commercial and business center of the Black Hills. Deadwood advertised itself as having two national banks and one state bank, a fine hotel, elegant stores, a fine water and sewer system, electric light and gas works, seven churches, the best public schools in the West, a Masonic temple, and several newspapers. (Courtesy Black Hills Mining Museum, Lead.)

DEADWOOD IN 1914. In the 1920s and 1930s, tourism began to develop in the Black Hills. Deadwood promoted its scenery as well as various tourist attractions, including the Adams Museum, Mount Moriah Cemetery, the Black Hills National Forest, and the Roosevelt Monument. (Courtesy Leland D. Case Library, BHSU.)

GOLDEN REWARD COMPANY. Harris Franklin, Ben Baer, Seth Bullock, George Hickok, and C. W. Carpenter organized the Golden Reward in May 1887. The company acquired numerous properties on the blanket formation of Ruby Basin and Bald Mountain. The first plant, built at a cost of $200,000 for the reduction of the refractory ore, was consumed by fire shortly after completion and quickly rebuilt. When the plant's reduction process proved unsuccessful, the company decided to try a chlorination process. In 1892, the company built a cyanide plant and increased its capacity for the treatment of ore by acquiring the Deadwood and Delaware Smelter.

GOLDEN REWARD. This mine was named the Golden Reward because it rewarded its owners with wealth. The *Times* reported on January 1, 1893, that it had been worked since 1887, delivering 75 to 100 tons of ore daily to the Golden Reward chlorination works. "Its supply," the paper remarked, "seems to be inexhaustible." Two railroads accessed the property: the Fremont, Elkhorn, and Missouri Valley and the Burlington and Missouri River. Ore bins were erected over each company's tracks.

GOLDEN REWARD MINE. Mules and horses were used for labor at the mines. This mule is pulling an ore car.

Gayville. There were a number of small towns clustered up the gulch along Deadwood Creek. Nearest to Deadwood, one of the first placer camps in the northern hills became known as Gayville. It was so-named for brothers William and Albert Gay. For many years, Albert ran a restaurant in Central City. His brother gained notoriety for killing Charles Forbes, a young man who sent a flirtatious letter to his wife. (Courtesy Black Hills Mining Museum, Lead.)

GAYVILLE CYANIDE NO. 2. The process of crushing ore and treating it with mercury to extract the gold worked well. In the 1890s, a process was developed where they would use the potassium or sodium cyanide to dissolve the remaining gold from the ore. Pictured here is the enormous 60-foot by 360-foot Cyanide Sand Treatment Plant No. 2, built by Homestake Mining Company between 1901 and 1902 to process the tailings from Pocahontas, Monroe, and Mineral Point (De Smet) stamp mill. It was in operation until 1934. Afterwards, it was used as an indoor ice skating rink until it was torn down in 1964. (Courtesy Black Hills Mining Museum, Lead.)

CENTRAL CITY. Approximately 2 miles above Deadwood, on January 20, 1877, citizens met and organized the town of Central City. The town grew with incredible speed, and by September of that year, Central City had gained a telegraph office and a post office. Three weeks after School District No. 8 first met in November, classes began with 51 students on December 10, 1877. One of the businesses in the new burg was Mrs. Parhurst's brewing company whose most important contribution to local life was producing a local libation called Gold Nugget Beer. By 1900, the population had dwindled to 448. (Left, W. R. Cross Collection, Leland D. Case Library, BHSU; below, Fred Borsch Collection)

FATHER DE SMET MINE. Located near Central City, the Father De Smet Mine was discovered on June 19, 1876. It was named for the well-known Jesuit missionary to the Native Americans, Fr. Pierre-Jean De Smet. Father De Smet is purported to have spent about four months in the Black Hills during 1848. By March 1879, the Father De Smet Mine was consolidated with several adjacent claims to form the Father De Smet Consolidated Gold Mining Company. Adjoining mines included the Justice Lode, the Occidental Lode, and the Golden Gate and its mill. Soon after his arrival in 1877, George Hearst became interested in the company. By early 1881, Heart's Homestake Mining Company had purchased enough shares to become the controlling interest in the Father De Smet. (Above, photograph by John Grabill; courtesy of the Library of Congress Prints and Photographs Division, LC-USZ78500; right, Leland D. Case Library, BHSU.)

BLACKTAIL, TERRAVILLE, AND CENTRAL CITY. This elevated view shows the close proximity of the towns of Deadwood Gulch to one another. In the foreground is Blacktail, in the upper right is Terraville, and in the upper left is Central City. Not visible in this photograph is the flight of 280 stairs that connected Central City and Terraville. Some of the mines in Blacktail Gulch were the Esmeralda, Hidden Treasure, Wooley-Pecaho, and High Lode. (Courtesy W. R. Cross Collection, Leland D Case Library, BHSU.)

LOOKING TOWARD MAITLAND ACROSS CENTRAL CITY. Maitland, named for the ex-governor of Michigan, was another mining district. Alexander Maitland took over the Penobscot Mine in 1902 and the town and mine were named for him. The U.S. War Production Board closed the gold mines during World War II, at a time when the Maitland mines ranked third in production in the northern Black Hills. Due to a lack of capital, the mines and mill did not reopen after the war. The Maitland mill burned to the ground around 1959, and Maitland was no more.

COLUMBUS CONSOLIDATED GOLD MINING COMPANY MILL, MAITLAND. Columbus was one of the active mines in the Maitland area. In 1902, the Columbus Consolidated Gold Mining Company took control of 645 acres north of Deadwood Creek, including the Columbus Mine. They deepened and enlarged the original mine shaft to 500 feet, but the mill shut down in 1904. Homestake, situated to the northwest, explored the shaft, but apparently did not find it promising enough to acquire it. The other mines in the area were known as the Beltram, Gold Eagle, Echo, and Penobscot. (Courtesy Adams Museum.)

TERRAVILLE, 1890S. The Golden Terra, an extremely rich mine, was the first quartz mine to be located in the gulch. Terraville was thought to have been named for this mine. The sound of the 220 dropping stamps crushing ore no doubt daily reminded the citizens of the town's namesake. In 1880, seven hundred seventy-five people, mostly miners, populated the town. (Courtesy Black Hills Mining Museum, Lead and Leland D. Case Library, BHSU.)

EAST OF TERRAVILLE. The Caledonia, the Deadwood-Terra, and Terraville stamp mills pounded away in the Terraville area. Eventually, Homestake would acquire the mills and mines and consolidate them.

DAY SHIFT AT THE DEADWOOD-TERRA. Workers stop for a photograph at the Deadwood-Terra hoisting plant. The original Deadwood and Golden Terra Mines were consolidated into the Deadwood-Terra Mine. By 1900, the principal shaft reached a depth of 900 feet.

WINTER SCENE, RESIDENCES. The population of Terraville dropped to 635 by 1900. Many of its residents were Finnish immigrants. When the mills began to close, the population dwindled. In 1964, only 200 people still lived in Terraville. Though the mills were long gone, the foundations remained, giving testament to another time.

OVERVIEW OF TERRAVILLE. As the town grew, boardinghouses sprang up in Terraville. Unmarried miners needed places to stay and eat their meals; to accommodate them, boardinghouses and hotels were built. Irma Klock wrote that Jack Gray, proprietor of the Caledonia House in Shoemaker Gulch, had difficulty with his help. Sixty men boarded at his place one time, and the hired girls on his staff flirted so much with the tenants that their work did not get done—so he hired a male staff. (Courtesy Leland D. Case Library, BHSU.)

WEST AND NORTH OF TERRAVILLE. Terraville was not known for its business district, but it did have a school, a church, boardinghouses, and Hearst's store. Later Homestake added a hospital annex for its employees. In the 1980s, when Homestake expanded its surface operation with the Open Cut, it removed the town of Terraville.

CLEAN-UP AT THE DEADWOOD-TERRA, 1888. Only trusted employees were allowed to scrape the amalgam off the tables, usually under the watchful eye of an armed guard. Operations shut down periodically to allow workers to clean out the gold residues from the equipment. The stamp mill process only worked for surface free-milling ore but was not suitable for deep refractory ores. Homestake acquired Terraville's Deadwood-Terra Mill in 1899 and renamed it the Pocahontas. At its peak of production, the Pocahontas dropped 700 stamps and had four mill buildings on the premises. (Photograph by John Grabill; courtesy Library of Congress Prints and Photographs Division, LC-USZ62-22481.)

CALEDONIA NO. 1, DEADWOOD-TERRA NO. 2, AND TERRA NO. 3, 1888. Homestake also acquired the Caledonia (also located at Terraville) in 1900. Renamed the Monroe, the mill dropped 800 stamps and used five buildings before it was discontinued in 1925. (Photograph by John Grabill; courtesy Library of Congress Prints and Photographs Division, LC-USZ62-17768.)

PLUMA. Located between Deadwood and Lead at the confluence of Whitewood and Gold Run Creeks, Pluma was noted for its electrical generating plant, an ice plant, and the Kildoan and Hawkeye Mills. The mills processed ores from several surrounding mines and were conveniently located at the junction of the Burlington and Missouri River and Deadwood Central Railroads. (Courtesy Black Hills Mining Museum, Lead.)

THE HORSESHOE GOLD MINING COMPANY MILL UNDER CONSTRUCTION. Prior to 1902, the mining company produced over $2.5 million in gold, mainly from the chlorination plant in Pluma. The plant later became a cyanide plant. The large exposed bodies of ore were classified as cyaniding and smelting ores. (Courtesy Adams Museum.)

MOGUL CYANIDE PLANT AND BELT LIGHT AND POWER PLANT AT PLUMA. According to Mildred Fielder in *Black Hills Guide to Ghost Towns*, the Horseshoe Mining Company lost $400,000 in property to a fire. The Mogul Mining Company, owned by B. J. Scanull, purchased all of the Horseshoe Mining Company property and assets. The Kildonan plant was renamed the Mogul Cyanide Plant. The Burlington and Missouri River and the Deadwood Central Railroads both served Pluma. (Courtesy Adams Museum.)

MILL AND POWER PLANT. The road to the right leads to Gold Run Gulch and Lead. Some of the Homestake workings are on the far hill; however, they are not visible in this photograph. (Courtesy Black Hills Mining Museum, Lead.)

ELECTRIC PLANT. The cooling system of the electric light plant at Pluma—the Belt Light and Power Company—was built at a cost of $12,000. By 1908, the population of Pluma dwindled to 40. When the mills closed and the railroads quit running, Pluma lost its post office and importance. (Courtesy Black Hills Mining Museum, Lead.)

Seven
Ruby Basin and Bald Mountain Mining Districts

BALD MOUNTAIN. Bald Mountain appears majestic in this photograph. Many mines were worked in this area, but unfortunately, their ore was difficult to treat. The hard rock did not yield to ordinary methods of reduction. Nevertheless, by consolidating with others, many mines managed to stay in production for a number of years. Eventually mining was no longer lucrative, and the mines shut down.

Terry. Strung along the gulch, the mining town of Terry took its name from nearby Terry Peak, which was itself named after Gen. Alfred H. Terry. Increased local mining activity boosted the town's growth, and by 1900, Terry was home to 1,188 residents. When the mines played out, the town's population and its businesses departed. In 1980, Terry, like Terraville, met its demise due to Homestake's expanded surface mining. Today only the cemetery remains. (Below, courtesy South Dakota State Historical Society.)

TERRY. Terry does not seem to have had the reputation as a wild-west town. It appears to have been a more business-oriented settlement. By 1904, it had two schools, three hotels, Catholic and Methodist churches, and an emergency hospital, a branch of the Lead hospital. According to the *Black Hills Illustrated* of 1904, Terry was one of the highest mining towns, at an elevation of 5,700 feet. It further opined, "The site of Terry is one of the most beautiful in the Hills. Not withstanding the altitude. Two of the mining companies with mines in that area were the Golden Reward and the Horseshoe." The 1904 *Black Hills Illustrated* reported that the first workings in Terry were at the Welcome Mine, which became part of the Horseshoe Mine. Both the Fremont, Elkhorn, and Missouri Valley and the Deadwood Central Railroads served the town. (Below, courtesy Fred Borsch Collection.)

MINE OPERATIONS NEAR TERRY PEAK. In 1904, the Golden Reward and the Horseshoe Mining Company were considered Terry's bread and butter. The Horseshoe Company had built a cyanide plant on the hill above the town, and the Golden Reward operated a mill and smelter at Deadwood.

HOIST. Steam powered the hoists until 1906 when the first electric motors appeared. Located at the shafts, hoists lowered men, materials, and supplies to levels far below the surface. Cages lowered and hoisted the men and materials, and skips hoisted the ore. Both operated much like elevators. The hoists in the Homestake shafts were considered among the world's largest; they could hoist their 60,000-pound loads at express speeds.

DEADWOOD STANDARD GOLD MINING COMPANY. Deadwood Standard Gold Mining Company held approximately 210 acres of patented land next to the Spearfish Gold Mining property. The company was organized in 1900 in order to work the former Hanscha and Slavonian Mines. Production stopped in 1904, but from 1912 to 1914 and 1916 to 1917, the Elk Mountain and Milling Company worked the property. The *Black Hills Mineral Atlas* lists total production of this mine as 78,060 tons of ore, yielding silver and gold valued at $11,983.29. (Courtesy Leland D. Case Library.)

BIG BONANZA SHAFT NEAR FANTAIL GULCH. The Big and Little Bonanza Mines were located in the Ruby Basin Mining District on the Deadwood formation. The Big Bonanza Mine, located between Fantail and Stewart Gulches, was operated independently until purchased by the Clinton Group in the early 1890s. In 1904, Lundberg, Dorr, and Wilson bought the mine. According to the *Black Hills Mineral Atlas*, the neighboring Little Bonanza Mine was part of the original 1877 holdings of the Golden Reward Gold Mining Company, whose tunnels extended south from Fantail Gulch. Lundberg, Dorr, and Wilson opened a 100-ton cyanide mill in Terry in 1904. *Black Hills Illustrated* stated that the mill was the first in the Black Hills to use electricity. The company operated the mill until 1913. (Courtesy Leland D. Case Library.)

PORTLAND HOIST HOUSE. The ruins of the Portland hoist house, the schoolhouse, and the powerhouse and tram snow shed are shown in this photograph. The Portland Mining Company was originally established in 1879. The company formed a new company in 1883 and called itself the Portland Consolidated Milling and Mining Company. In 1884, the Portland Company purchased the Trojan Mine. The Trojan Mining Company was established in 1911 and acquired the Portland Mining Company after the Portland Mining Company merged with the Clinton Mining Company. The photograph below shows the interior of the Portland hoist house. The tramline is also visible. (Both, courtesy Library of Congress Prints and Photographs Division, Haer SD 41–Lead V.1-127, V.1-140.)

Tramline. Ore cars were left as they were when the once-lucrative Clinton Mine shut down. In 1900, the Portland Mining Company purchased the Clinton Mine, which continued to be an active mine through 1959 under the management of the Bald Mountain Mining Company. Even though gold was discovered in the Trojan area in 1877, it was not until the 1900s that the mines were consolidated. The Trojan area took out about $20 million in gold. (Courtesy Library of Congress Prints and Photographs Division, Haer SD 41–Lead V.1-152.)

Trojan Miners. In 1893, the Bald Mountain district was booming. Thousands of dollars had been extracted from the rich ores in the area. Capitalists had been attracted to the area to establish the facilities necessary for mining and milling. These immense bodies of ore were easily accessible with plenty of wood and water to carry on the necessary operations. (Courtesy Black Hills Mining Museum, Lead.)

99

TROJAN TOWN BUILDINGS. Portland, later named Trojan, enjoyed a population of 500 people in 1893. These former town buildings were moved to a hill north of Trojan in the mid-20th century. Trojan became one of the most recently abandoned towns in the area after the mines shut down in 1959. (Courtesy Library of Congress Prints and Photographs Division, Haer SD 41–Lead V.1-125.)

TWO JOHNS MINE TRAMLINE. Named for a stage play, the Two Johns Mine was located in the Trojan area. The Two Johns's gasoline locomotives hauled its ore up a steep grade of tramline to the mill. In 1911, the Portland Mining Company reorganized as the Trojan Mining Company and later purchased the Two Johns in 1917. The Two Johns was one of the main suppliers of ore when it was owned by the Bald Mountain Mining Company from 1928 to the 1940s. (Courtesy Library Congress Prints and Photographs Division, Haer SD 4–Lead V.1-156.)

TWO JOHNS HOIST HOUSE. During both world wars, mining operations were cut back. When mining resumed after World War II, expenses had increased, the labor force had decreased, and gold prices were low. However, a peak of production was reached in 1952 at 370 tons per day. The active mines in the Trojan area closed in 1959, and the Two Johns's buildings and hopes were abandoned. (Courtesy Library of Congress Prints and Photographs Division, Haer SD 41–Lead V.1-159.)

EAGLE MINE CRUDE ORE BIN. The American Eagle Mining Company was organized by a group of Minneapolis and St. Paul businessmen from 1906 to 1910 and consisted of 12 claims. The Trojan Mining Company acquired the Eagle Mine in 1911, and the Bald Mountain Company owned the American Eagle from 1928 to 1959, in addition to many other properties covering 3,000 acres in the Bald Mountain and Green Mountain area. (Photograph by Joel Waterland; courtesy Library of Congress Prints and Photographs Division, Haer SD 41–Lead V.1.)

SPEARFISH GOLD MINING AND REDUCTION COMPANY, AROUND 1907. The Spearfish Gold Mining and Reduction Company formed in 1900. It was incorporated under Colorado law with W. S. Jackson of Colorado Springs, Colorado, as president and O. N. Brown of Cyanide, South Dakota, as general manager. The company was formed to consolidate several groups in the Ragged Top mining district. They included the Metallic Streak claims belonging to the Hattenbach brothers of Deadwood and the Hermitage and Black Diamond groups. The town of Cyanide was developed nearby, possibly named for the Spearfish Gold Mining Company's cyanide plant. (Courtesy Leland D. Case Library.)

Eight

Lead and Homestake

Lead (Pronounced Like "Heed"). In 1904, a *Black Hills Illustrated* article describes Lead as "one of the most prosperous municipalities in the West and one of the best governed." Lead's story began in February 1876 when Thomas E. Carey left Deadwood in search of placer gold and found rich deposits on what was later called Gold Run Creek. It was not long before other miners relocated to this area, and talk began of laying out a town. The miners chose a site for their town between the north and south forks of Gold Run Creek. There were a large number of leads (ore outcroppings) in the area, so they chose the name "Lead City." On July 10, 1876, a large group of men set out to lay out streets and town lots. In August 1890, an overwhelming majority of the community's citizens voted to incorporate, and they dropped the word "City" from the name. Cyrus H. Enos was elected Lead's first mayor. Two nicknames for the town were "City of Mills" and "Metropolis of the Black Hills."

BAKERY IN LEAD. On July 10, 1876, Lead City laid out its town lots. Owners of the lots were required to build on them in 60 days or forfeit them. By early 1877, four hotels, a grocery store, saloon, bakery, and a butcher shop were in operation. Fred Schutze owned this bakery on Main Street. He was a prominent businessman and was active in a local German American organization. (Courtesy Black Hills Mining Museum, Lead.)

HOMESTAKE HOTEL. By 1877, four hotels were constructed in Lead. One was the Homestake Hotel to house the Homestake Mine's employees. Built in 1882, the hotel featured a dining room that seated 150 people. It was damaged by fire on March 3, 1903, but was quickly rebuilt and expanded with a new brick addition. The other hotels at the time were the Miner's, the Springer, Abt, the Martin, the St. Elmo, and the Globe. (Courtesy Leland D. Case Library, BHSU.)

HEARST MERCANTILE. The existence of Lead City and the Homestake Mine were closely interwoven. The Homestake Mining Company took an interest in the welfare of the community, which generated both positive and negative effects. George Hearst, the head of Homestake, established a company store in 1879 to give the mine workers and their families a place to shop and to provide a local source for acquiring supplies that the mine needed. The store was the first brick building constructed in the hills, and by all reports, it carried almost everything. Critics argued that Hearst Mercantile was a typical company store, that Homestake employees were required to do their buying there, and that by extending the workers and their families unlimited credit, the mercantile was intentionally binding them to the store, and hence, functionally enslaving them to the mining company. However, others maintain that mine employees were under no compulsion to buy from the Hearst Mercantile and could shop wherever they liked. (Courtesy Black Hills Mining Museum, Lead.)

PHOEBE HEARST. George Hearst died in 1891. However, his philanthropist wife, Phoebe, continued to make substantial contributions to the educational and cultural life of Lead. She helped support the Lead kindergarten and arranged for the construction of the Homestake Mining Company Opera House, which also housed the town's recreation building as a gift to the Lead community. Tickets were required for the opera house, but the use of the swimming pool, bowling alley, library, and meeting rooms were free to all residents. (Courtesy Black Hills Mining Museum, Lead.)

LEAD ASSAY OFFICE. Assay offices determined the quantity of metal in an ore or alloy. An assay was helpful to provide information necessary for exploration and development of mining and milling. This Homestake assay office was located originally near the old 80-Stamp Mill. It was moved in 1896 to the east end of Lead's Main Street. (Courtesy Black Hills Mining Museum, Lead.)

LEAD FOURTH OF JULY PARADE, 1902. Lead's citizens enjoyed their holiday celebrations. The Fourth of July was usually celebrated with picnics, parades, and orations. More dear to the mine-laborer's heart was Labor Day. On this holiday, the bands and lodges were out in full force. (Courtesy Black Hills Mining Museum, Lead.)

BAND. This band, dressed in their stylish uniforms, could possibly be preparing to perform for a Fourth of July celebration or for the Homestake Field Day. (Courtesy Black Hills Mining Museum, Lead.)

BACHELOR CLOWN DANCE. Lead enjoyed many social clubs; there was a civic organization for almost every occasion. The Bachelor Club sponsored this bachelor clown dance. There was an organization for Civil War veterans, a Woman's Club, the Society for Black Hills Pioneers, the Miner's Union, and the Ancient Order of United Workmen, in addition to other labor organizations.

Then there were the lodges, which consisted of the Masons, Odd Fellows, Degree of Honor, Royal Neighbors, Rathbone Sisters, and many others. Most nationalities also had lodges. (Courtesy Black Hills Mining Museum, Lead.)

Scottish Clan Stewart, Lead

SCOTTISH CLAN. By 1910, the mile-high city of Lead enjoyed a population of 8,392, then the second-largest community in South Dakota. Employment opportunities abounded for immigrants, miners, laborers, mechanics, and anyone who wanted to work. The Scottish people came to Lead from the British Isles. The Clan Stewart branch of the Order of Scottish Clans became very involved in the town. They helped maintain their heritage by organizing a bagpipe and drum troupe that performed in the area. (Courtesy Black Hills Mining Museum, Lead.)

LAUNDRY. The Martinez family operated this laundry in Lead, located on Gold and Julius Streets. As families populated the Black Hills, women assumed their traditional roles such as teaching, managing, or working at the boardinghouses, restaurants, hotels, and laundries. (Courtesy Black Hills Mining Museum, Lead.)

THE TERRAVILLE TUNNEL. The mining company dug a tunnel between Terraville and the Abe shaft in Lead for the purpose of moving supplies more efficiently. The people who lived in Terraville often did their shopping in Lead and used the lighted tunnel as a passageway between the two towns. (Courtesy Black Hills Mining Museum, Lead.)

OPEN CUT AT HOMESTAKE. Fred and Moses Manuel and Hank Harney discovered an outcropping of ore called a ledge or lead and staked the Homestake claim on April 9, 1876, on what is now known as the Open Cut. Moses Manuel left Portland, Oregon, for the Black Hills. Along the way, he met up with his brother Fred in Helena, Montana. After a winter of prospecting in the Black Hills, they discovered the Homestake Ledge. During the spring of 1876, they took out $5,000 in gold, but little did they know the extent of their discovery.

OPEN CUT, GEOLOGY. The Open Cut began as a solid mountain where the Manuel brothers and Hank Harney staked their Homestake claim. Between 1876 and 1945, approximately 40 million tons of rock was taken from this mountain, and 15 percent of the rock removed was gold-bearing ore. The geological story is exposed in the colorful strata of the Open Cut. Scientific research has indicated that the rocks in the bottom of the Open Cut may well date to two billion years ago, even before life appeared on earth.

OX TEAMS. In 1878, an 80-stamp mill was shipped from San Francisco by rail to Sidney, Nebraska. Since the railroad ended at Sidney, ox teams hauled the mill a distance of almost 300 miles to Lead. By July 1878, the stamps began dropping on the ore. Ox and mule teams also brought in supplies for the local merchants and other mining and railroad equipment, as well as the first three engines for the Homestake railroad. The freighter Louis LaPlant hauled the first railroad steam locomotive to the Black Hills in 1879 from Bismarck by ox team. Named the "J. B. Haggin," the 5-ton locomotive was used as a mine engine and hauled ore and supplies around Lead. Today the engine can be seen on the main floor of Deadwood's Adam Museum.

MINES AND ORE CAR. Mining was hard work. Before 1900, when pneumatic drills and other labor-saving devices came into use, work was done by hand, both in open-cut and underground mining.

MINER BREAKING ROCK. A miner breaks up the large rock to be placed in an ore car. Early miners used candles for lighting their way. Miners afterwards wore kerosene or "sunshine lamps," which in turn, around 1913, started to be replaced by carbide lamps. Electric cap lamps came into use in 1934. (Courtesy Black Hills Mining Museum, Lead.)

PNEUMATIC DRILLS. In 1900, the post-mounted compressed air pneumatic drills replaced hand-drilling. These new drills were not ideal either, though: they were heavy and produced large amounts of dust. The combination of dust and poor lighting made work difficult. Post-mounted leyners, operated with water, were used in the 1920s and 1930s, but these dulled quickly due to the ore's hardness. After this, diamond drills and tungsten carbide drill bits became the norm.

WORKING IN THE MINE. Early mines used large amounts of timber to support rock. Workers found themselves in precarious situations as they mined at Homestake and other mines. It appears that these miners are in a stope, an underground room where the ore is mined out. Not refilling these underground caverns with backfill eventually caused the ground above to sink and cave in.

OPEN CUT. Between 1918 and 1940, the old mills, hoist rooms, head frames, and other buildings in the Open Cut vicinity were dismantled and removed. The center of Lead began to sink as abandoned stopes collapsed, far beneath the soil. Consequently, Homestake moved its surface works, and Lead moved its business district. New plants were built on the ridge southeast of the Open Cut. In 1922, the South Mill was begun, the Ross Shaft was installed in 1934, and the Yates Shaft's installation was completed in 1941.

HORSES AND MULES. "The Homestake Mine purchased two small mules to operate in the lower levels of the mines," reported the July 17, 1888, *Black Hills Daily Times*. "One of them was laid down, tied hand and foot and let down on a cage to the 500-level yesterday. His mate will go down today." After 1901, compressed-air locomotives placed underground reduced the number of horses and mules used in the mines.

HOMESTAKE MILLS AND MINES, 1889. At Homestake, the milling process consisted of breaking down the ore so finely that the gold particles were released from the rock and then further separated by a chemical process, which finally produced pure gold. The hard-earned gold averaged approximately one-quarter of an ounce or less to a ton of rock. (Photograph by John Grabill; courtesy Library of Congress Prints and Photographs Division, LC-Dig-ppmsc-02674.)

STAMP MILL INTERIOR, HOMESTAKE. Ore arriving at the mill was dropped on a grid of iron bars, designed to keep the larger pieces of ore out of the crusher. A worker used a sledge to break up the large pieces. The ore was reduced to coarse powder by a jaw-type crusher before it went into the stamp mills. Arranged in batteries of five, weighing 800 pounds each, the stamps could grind from 1.5 to 2 tons a day. The stamps, working in a water-filled mortar, ground the ore to the fineness of flour. Mercury could be added to attract the gold. It then passed through a fine screen in the mortar and flowed over copper tables coated with mercury, which caught the gold by forming an amalgam. (Courtesy Leland D. Case Library, BHSU.)

HIGHLAND HOISTING WORKS, HOMESTAKE. The Open Cut, site of Homestake's early surface works, was occupied for almost 50 years. Homestake's hoisting works surrounded the Open Cut with Old Abe sitting to the east, the Highland to the west, and the Golden Star directly in front of the cut. The Burlington and Missouri River Railroad No. 2 was added in the 1920s to carry cordwood for the mills. (Note the cordwood on the hillside.) On May 10, 1901, a large boiler exploded and destroyed a massive section of the building pictured here with the smokestacks, killing Ed Brelsford and injuring others. The explosion's force shattered windows on Mill Street in Lead. (Courtesy Adams Museum.)

HOMESTAKE MINE AND LEAD CITY, 1891. In the early years of mining, at least 14 different mining companies existed in the Open Cut area. When the Highland, the Deadwood Terra, the Father De Smet, and the Caledonia were consolidated with Homestake by 1901, the mining operation expanded and an era of modernization had begun. (Courtesy Library of Congress Prints and Photographs Division, LC-USZ62-89966.)

FLYWHEEL. Direct-current motors from flywheel motor-generated sets operated the hoists. The balanced flywheels equalized the power demand by storing energy while the hoists were not used and releasing energy when the hoists were raising men, ore, and materials.

AIR COMPRESSOR. Compressors occupied two main air-compressor plants at Homestake. More than 25,000 cubic feet of air per minute was compressed, cooled, and piped underground through a hundred miles of air line to operate pneumatic equipment.

HYDROELECTRICITY AT SPEARFISH CANYON. Homestake owned the water rights and most of the mineral claims in Spearfish Canyon. The company constructed tunnels and blasted through rock for pipelines to carry water to its hydroelectric plants. A generating plant was established to provide some of the power required for Homestake. The annual energy consumption for Homestake was equal to the amount of electricity needed to supply a number of South Dakota cities. (Courtesy Black Hills Mining Museum, Lead.)

MAURICE HYDROELECTRIC PLANT NO. 2, SPEARFISH CANYON. A hydroelectric plant located at Englewood near Lead provided the area's first electrical service. Later Homestake would build three hydroelectric plants to generate its own electricity, and even these provided the company with only about a third of the power it needed. Additional power was purchased from the local utility companies. (Courtesy Black Hills Mining Museum, Lead and the Minnilusa Historical Association.)

BLACK HILLS AND FORT PIERRE RAILROAD. Homestake began its own railroad in 1881. It was first known as the Black Hills Railroad, and in June 1882, it was renamed the Black Hills and Fort Pierre Railroad (though it never reached Fort Pierre). It was built to transport ore, wood, and heavy machinery between Lead and the town of Piedmont on the hills' outskirts, where it would connect to the standard-gauge Fremont, Elkhorn, and Missouri Valley Railroad. The Black Hills and Fort Pierre Railroad also carried passengers when necessary. The railroad's trains traveled a steep and twisting track, making for a trip which one newspaper writer compared to "an angle worm in excruciating torture." In July 1901, the Black Hills and Fort Pierre Railroad was put under the agency of the Chicago, Burlington, and Quincy Railroad Company and under management of the Burlington and Missouri River Line. The railroad was abandoned on January 13, 1930.

RAILROAD, ELK CREEK. In 1889, the Black Hills and Fort Pierre Railroad extended east from Bucks to Elk Creek, the Homestake's woodcutting area. The rails followed Elk Creek Canyon, a beautiful but curvy route, fostering the idea that perhaps service could be provided to passengers looking for a scenic outing. By 1889, the line offered excursions and transportation to the lumber camps. (Courtesy Leland D. Case Library, BHSU.)

RAILROAD CONSTRUCTION GANG, 1890. The construction of the Chicago, Burlington, and Quincy Railroad began in South Dakota near Edgemont on May 15, 1890. The construction workers worked their way north, motivated by approaching winter and their desire to beat the Fremont, Elkhorn, and Missouri Valley Railroad to Deadwood—but this would not be an easy task.

CHICAGO, BURLINGTON, AND QUINCY RAILROAD. The Chicago, Burlington, and Quincy Railroad had shuttled traffic to and from the mines during the early 1900s. The line eventually absorbed all of its subsidiary companies and remained in service.

HOMESTAKE. During World War II, the war production board suspended gold-mining operations, though some workers remained at the Homestake foundry machine shop to produce goods needed for the war effort. The following decades saw modernization of mining techniques and procedures, including computerization. The mine's workers voted in 1966 to be represented by the United States Steel Workers Union. On September 2000, a Homestake Mining Company spokesman announced that the mine would close. In January 2002, the Homestake shut down after more than 125 years of operation, having mined 41 million troy ounces of gold—worth more than $24 billion at gold prices of over $600 per ounce. So ended a prosperous era. In 2007, Homestake was selected among four finalists to become a deep underground laboratory and to be named the Sanford Underground Science and Engineering Laboratory. (Photograph by Locke and McBride.)

Bibliography

Baldwin, George P. *Black Hills Illustrated: a Terse Description of Conditions Past and Present of America's Greatest Mineral Belt.* Philadelphia: Baldwin, 1904.
Black Hills Daily Times, Deadwood, Dakota Territory.
Bohmker, Tom. *Gold Panner's Guide to the Black Hills of South Dakota.* Independence, OR: Cascades Mountains Gold, 2005.
Fielder, Mildred. *A Guide to Black Hills Ghost Mines.* Aberdeen, SD: North Plains Press, 1972.
———. *Silver is the Fortune.* Aberdeen, SD: North Plains Press, 1978.
Hughes, Richard B., *Pioneer Years in the Black Hills.* Rapid City: Dakota Alpha Press, 2002.
Klock, Irma H., *The Gold Camps in Upper Deadwood Gulch.* South Dakota: Klock, 1984.
Parker, Watson and Hugh K. Lambert. *Black Hills Ghost Towns.* Chicago: Swallow Press, 1974.
Parker, Watson. *Gold in the Black Hills.* Norman, OK: University of Oklahoma, 1966.
Tallent, Annie. *The Black Hills or Last Hunting Grounds of the Dakotahs.* Sioux Falls: Brevet Press, 1974.
Toms, Donald. *The Gold Belt Cities: Deadwood and Environs.* Lead, SD: GOLD, 1988.
———. *The Gold Belt Cities: Lead and Homestake.* Lead, SD: GOLD, 1988.
U.S. Bureau of Mines, Region V. *Black Hills Mineral Atlas: South Dakota* (two volumes). Pittsburgh: U.S. Bureau of Mines, 1954, 1955.

Discover Thousands of Local History Books
Featuring Millions of Vintage Images

Arcadia Publishing, the leading local history publisher in the United States, is committed to making history accessible and meaningful through publishing books that celebrate and preserve the heritage of America's people and places.

Find more books like this at
www.arcadiapublishing.com

Search for your hometown history, your old stomping grounds, and even your favorite sports team.

Consistent with our mission to preserve history on a local level, this book was printed in South Carolina on American-made paper and manufactured entirely in the United States. Products carrying the accredited Forest Stewardship Council (FSC) label are printed on 100 percent FSC-certified paper.

MADE IN THE USA